ICONS

INDIAN STYLE

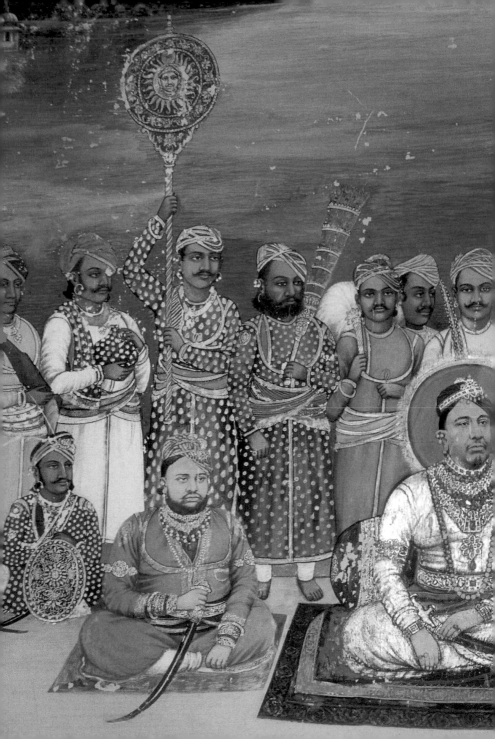

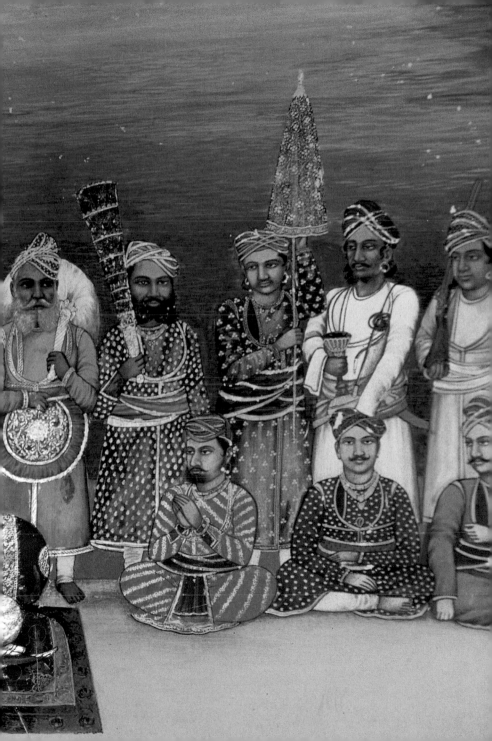

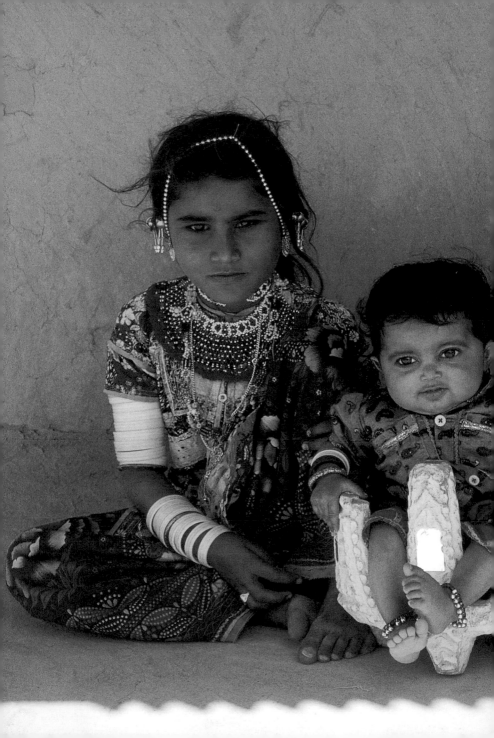

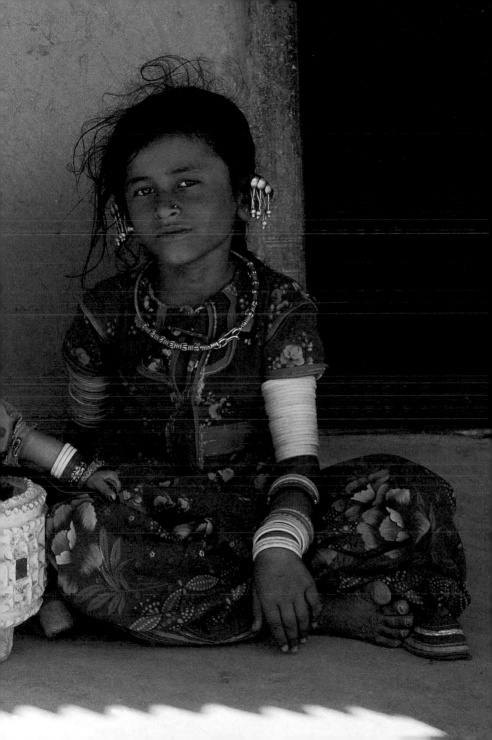

INDIAN

Landscapes Houses

Interiors Details

STYLE

PHOTOS **Deidi von Schaewen** EDITOR **Angelika Taschen**

TASCHEN
KÖLN LONDON LOS ANGELES MADRID PARIS TOKYO

Cover: Wooden images of Indian deities.
Couverture: Statuettes de divinités indiennes en bois.
Umschlagvorderseite: Indische Götterfiguren aus Holz.

To stay informed about upcoming TASCHEN titles, please request
our magazine at www.taschen.com or write to TASCHEN,
Hohenzollernring 53, D–50672 Cologne, Germany, Fax: +49-221-254919.
We will be happy to send you a free copy of our magazine which is
filled with information about all of our books.

Edited by Angelika Taschen, Cologne
Cover design by Angelika Taschen, Claudia Frey, Cologne
Texts edited by Ursula Fethke, Cologne, Petra Frese, Dortmund
Lithography by Thomas Grell, Cologne

Printed in Italy
ISBN 3–8228–5562–6

CONTENTS SOMMAIRE INHALT

"God is love. Is this the final message of India?" asks E. M. Forster in his novel of 1924, *A Passage to India*. India is a land full of love and devotion, made so by the intense religiosity and profound spirituality of the people who live there and by its ancient culture. When we travel through India with our eyes and our hearts open, we can feel this devotion and love in every detail, every encounter, every home, every temple and even in the smallest domestic altar, be it in a poor or wealthy household.

The maharajas invested their riches in beauty, in exotic, fairy-tale palaces of white marble and honeyed stone, in exquisitely fashioned jewels and robes. But even materially poor Indians expend all their love on making themselves and their surroundings more beautiful. Their ornaments are intricate and inexpensive henna tattoos on their hands and feet,

WHY IS INDIA SO BEAUTIFUL?

Angelika Taschen

*«Dieu est amour. Est-ce là le dernier message de l'Inde?»,
demande E. M. Forster en 1924 dans son roman «Route des
Indes». L'Inde déborde d'amour et de ferveur, cela tient à la fois
à l'intense religiosité et à la profonde spiritualité de ses habitants
et à l'ancienneté de sa civilisation.
Si l'on voyage à travers l'Inde en ouvrant ses yeux et son cœur,
on ressent cet amour et cette ferveur dans chaque détail,
chaque rencontre, chaque maison, chaque temple et même à la
vue du plus petit autel domestique, et ce aussi bien chez les
riches que chez les pauvres.
Les maharajas ont investi leurs trésors dans la beauté, dans des
palais fantastiques, merveilleusement exotiques, de marbre
blanc ou de pierre couleur miel, dans des joyaux et des cos-
tumes précieux et somptueusement travaillés. Mais même lors-
qu'ils sont pauvres, les Indiens mettent toute leur ardeur à*

»God is love. Is this the final message of India?«, fragte E. M.
Forster 1924 in seinem Roman »A Passage to India«. Indien ist
ein Land voller Liebe und Hingabe, was an der intensiven Reli-
giosität und tiefen Spiritualität der dort lebenden Menschen liegt
und auf seiner sehr alten Kultur beruht. Wenn man mit offenen
Augen und offenem Herzen durch Indien reist, spürt man diese
Hingabe und Liebe in jedem Detail, bei jeder Begegnung, in
jedem Haus, in jedem Tempel und selbst beim Anblick des
allerkleinsten Hausaltars, sowohl im Reichtum als auch in der
Armut.
Die Maharajas haben ihre Schätze in Schönheit investiert, in fan-
tastische, märchenhaft exotische Paläste aus weißem Marmor
oder honigfarbenem Stein, in kostbare, kunstvoll verarbeitete
Juwelen und Gewänder. Aber auch die materiell armen Inder
verwenden ihre ganze Liebe darauf, sich und ihre Umgebung zu

which follow age-old traditions. They decorate their mud huts with cheap fragments of broken mirrors, and paint wonderful abstractions of peacocks, animals, flowers and gods on their walls in colourful pigments or plain white rice flour. The simple but artfully draped cotton saris worn so elegantly by the gracious Indian women are often dyed an intense pink or brilliant orange, while on their arms they wear hundreds of bangles, cheap plastic bracelets in an infinite variety of colours, which sparkle and gleam. Every old sheet of newspaper is lovingly folded into a bag and heavily scented necklaces are conjured out of jasmine blossoms. This love of beauty and decoration is an expression of love for the countless Indian deities, and the range of forms it thereby assumes is inexhaustible.

The Indian subcontinent reaches from the soaring peaks of the snow-capped Himalayas,

embellir leur environnement et leur personne. Ils se parent les mains et les pieds de tatouages au henné qui reposent sur des traditions ancestrales. Ils décorent leurs huttes en boue d'éclats de miroir et peignent sur les murs, avec des pigments de couleur ou de la simple farine de riz, de superbes représentations abstraites de paons, d'animaux, de fleurs ou de dieux. Les gracieuses Indiennes sont vêtues de saris simples mais savamment drapés, souvent teints en rose fuchsia ou en orange vif, et portent des centaines de «bangles», des bracelets bon marché en plastique qui étincellent de mille feux dans une palette infinie de couleurs. Comme par magie, une vieille page de journal se métamorphose en un joli petit sac en papier et les fleurs de jasmin sont transformées en colliers parfumés.
Cet amour de la beauté et de la décoration est l'expression de celui que les Indiens éprouvent pour leurs innombrables divini-

verschönern. Ihr Schmuck sind komplizierte Henna-Tattoos an Händen und Füßen, die auf uralten Traditionen beruhen. Ihre Lehmhütten verzieren sie mit billigen Spiegelscherben und malen mit bunten Farbpigmenten oder einfachem weißem Reismehl wunderbare Abstraktionen von Pfauen, Tieren, Blumen oder Göttern auf die Hauswände. Die einfachen, aber kunstvoll drapierten Baumwollsaris der graziösen Inderinnen sind oft in intensivem Pink oder knalligem Orange gefärbt, an den Armen tragen sie Hunderte von Bangles, billige Armreifen aus Plastik, die in unendlich vielen Farben funkeln und glitzern. Aus jedem alten Zeitungsblatt wird liebevoll eine schöne Tüte gefaltet und aus Jasminblüten intensiv duftender Schmuck gezaubert. Diese Liebe zu Schönheit und Dekoration ist Ausdruck der Liebe zu den zahllosen indischen Gottheiten und das daraus entstehende Spektrum an Gestaltungsmitteln ist unerschöpflich.

through the arid deserts and lush jungles of Rajasthan and the gentle backwaters of Kerala, down to Cape Comorin at its southernmost tip where two turquoise seas meet. Each of India's many landscapes has its own climate, and each region has different materials at its disposal and has thus evolved its own distinct style of architecture. At the foot of the Himalayas, houses are built with thick stone walls and small windows, while nomads in the desert pitch richly decorated open tents of light fabrics. The marble palaces found in cities, or even in the middle of a lake, give way in the jungle to houses made out of the wood of the jack-tree, and in barren countryside to huts of sun-baked earth.

Each of the many religions practised in India also brings with it its own visual imagery, characteristic ornaments and architectural style: Buddhism, which was founded here by an Indian prince who renounced riches and sought the path to enlightenment; Jainism, with its divinely beautiful temples; Islam, in whose name Moghul princes erected such

tés, et leur imagination est inépuisable quand il s'agit de le rendre visible.

Des hautes cimes neigeuses de l'Himalaya au Cap Comorin baigné des eaux turquoise de l'océan, à son extrémité sud, le sous-continent indien abrite aussi des déserts arides, les forêts tropicales du Rajasthan, et les rivières du riant Kerala. Les nombreuses régions traversées ont toutes un climat différent et des matériaux de construction spécifiques, chaque région a donc son style architectural propre. Au pied de l'Himalaya, les maisons ont des murs épais et de petites fenêtres, dans le désert, les nomades dressent des tentes ouvertes richement décorées, dans les villes ou encore au milieu d'un lac, se dressent des palais en marbre, dans la jungle on construit des maisons en bois de jaquier et dans les contrées arides, des cabanes en boue.

Der indische Subkontinent reicht von den höchsten Bergen des schneebedeckten Himalaya über die trockenen Wüsten und grünen Dschungel Rajasthans zu den Backwaters des lieblichen Kerala bis zur südlichsten Spitze Cape Comorin, wo zwei türkisblaue Meere zusammenfließen. Jede der vielen Landschaften Indiens hat ein anderes Klima und es stehen in jedem Gebiet andere Baumaterialen zur Verfügung, entsprechend hat jede Region ihren eigenen Baustil entwickelt. Am Fuß des Himalaya verfügen die Häuser über dicke Steinmauern und kleine Fenster, in der Wüste stellen die Nomaden reich verzierte offene Zelte auf, in den Städten oder mitten in einem See werden Marmorpaläste errichtet, im Dschungel Häuser aus dem Holz der Jackbäume und in kargen Landschaften Lehmhütten gebaut. Zudem bringt jede der vielen in Indien praktizierten Religionen eine eigene Bildsprache, charakteristische Ornamente und eine

architectural wonders as the Taj Mahal; and above all Hinduism, whose vast numbers of deities are everywhere to be seen – painted on walls, as figurines on domestic altars, as exquisitely carved statues in temples or as gaudily painted plaster figures on every street corner.

India is thereby the land with the greatest diversity of ways of life and forms of housing in the world. But all beautiful things here have one factor in common: they arise out of a devotion to God and a love of beauty.

En outre, chacune des nombreuses religions pratiquées en Inde a son vocabulaire pictural particulier, une ornementation caractéristique et une architecture bien à elle: le bouddhisme, fondé par un prince indien qui renonça à ses biens pour chercher la voie de l'Eveil, le jaïnisme avec ses temples d'une beauté céleste, l'Islam, au nom duquel les Grands Moghols firent édifier des merveilles architecturales comme le Taj Mahal et surtout l'hindouisme avec ses innombrables divinités en perpétuelle métamorphose qui se manifestent partout, en peinture sur les murs des maisons, sous forme de figurines sur les autels domestiques ou de magnifiques statues sculptées dans les temples.

Ainsi l'Inde est le pays qui présente les modes de vie et les formes d'habitat les plus différents. Mais toutes ces choses qui nous ravissent ont un point commun: elles trouvent leur origine dans l'amour du divin et du beau.

für sie typische Architektur hervor: Der Buddhismus, der hier von einem indischen Prinzen, der dem Reichtum entsagte und den Weg zur Erleuchtung suchte, begründet wurde, der Jainismus mit seinen überirdisch schönen Tempeln, der Islam, in dessen Namen die Mogulfürsten viele Wunderwerke der Architektur wie das Taj Mahal errichten ließen, und vor allem der Hinduismus mit seinen unzähligen, sich ständig verwandelnden Göttern, die überall in Erscheinung treten, auf Hauswände gemalt, als kleine Figuren auf dem Hausaltar, als kunstvoll gemeißelte Skulpturen im Tempel, als knallbunte Gipsfiguren an jeder Straßenecke.

So ist Indien das Land mit den meisten unterschiedlichen Lebensweisen und Wohnformen auf der ganzen Welt. Aber alle schönen Dinge haben hier eines gemeinsam: Sie entstehen aus Hingabe zu Gott und aus Liebe zur Schönheit.

"This is indeed India! The land of dreams and romance, of fabulous wealth and fabulous poverty, of splendour and rags, of palaces and hovels, of famine and pestilence, of genii and giants and Aladin lamps, of tigers and elephants, the cobra and the jungle, the country of a hundred nations and a hundred tongues, of a thousands religions and two million gods (...) – the one land that all men desire to see, and having seen once, by even a glimpse, would not give away that glimpse for the shows of all the rest of the globe combined."

Mark Twain, *Following the Equator* (1897)

«Voilà bien l'Inde! Le pays des rêves et du romantisme, d'une fabuleuse richesse et d'une fabuleuse pau- vreté, du luxe et des haillons, des palais et des cabanes, de la famine et de la peste, des génies, des géants et des lampes d'Aladin, des tigres et des éléphants, du cobra et de la jungle, le pays de centaines de nations et de langues, de milliers de religions et de deux millions de dieux (...) Le seul pays que tous les hommes rêvent de voir ou d'avoir vu une fois, ne serait-ce que pour un court moment qu'ils n'échan- geraient contre aucun trésor de ce monde.»

Mark Twain, *Le tour du monde d'un humoriste* (1897)

»Dies ist tatsächlich Indien! Das Land der Träume und der Romantik, des fabelhaften Reichtums und der fabelhaften Armut, des Glanzes und der Lumpen, der Paläste und der Hütten, der Hungersnöte und Pestepidemien, der Genies und Riesen und Aladinlampen, der Tiger und Elefanten, der Kobra und des Dschungels, die Heimat von einer Hundertschaft Nationen und Sprachen, von Tausenden von Religionen und zwei Millionen Göttern (...) – das einzige Land, nach dem sich alle Menschen sehnen, und wenn sie es einmal auch nur für einen kurzen Moment erlebt haben, so würden sie diesen Augenblick nicht für alle Schätze der restlichen Welt eintauschen.«

Mark Twain, *Dem Äquator nach* (1897)

LANDSCAPES

Paysages Landschaften

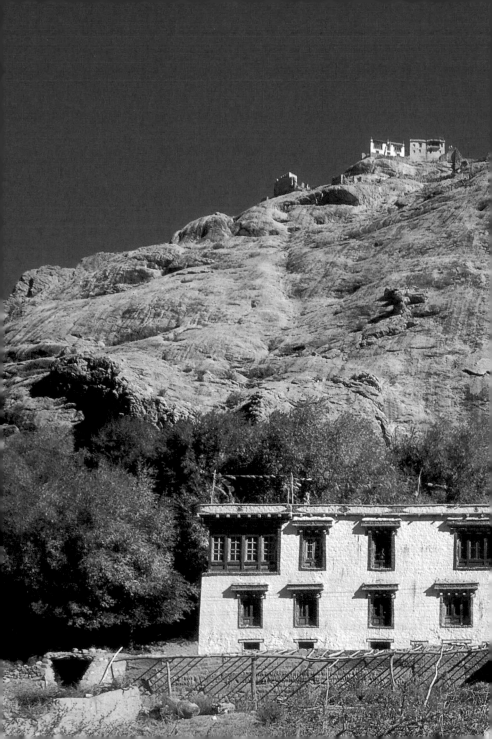

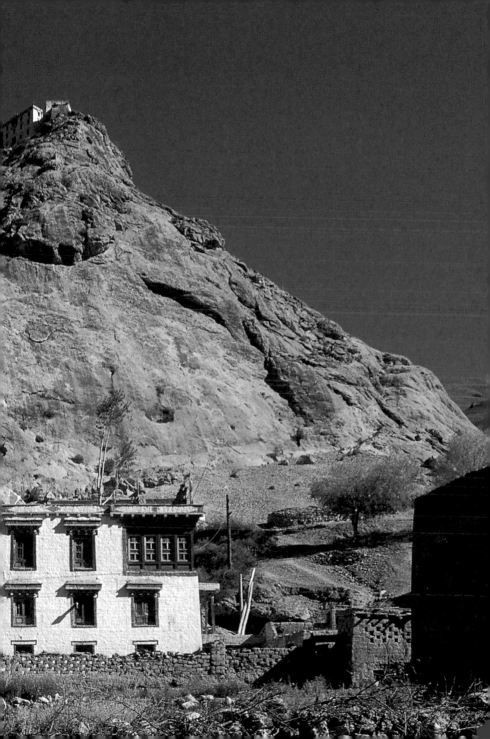

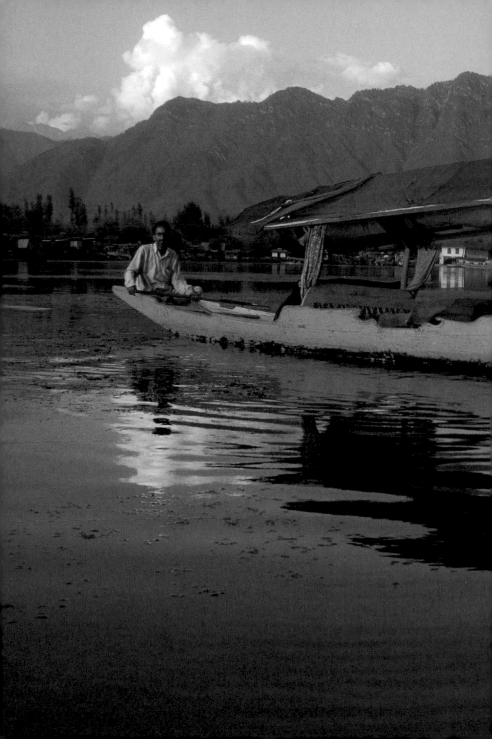

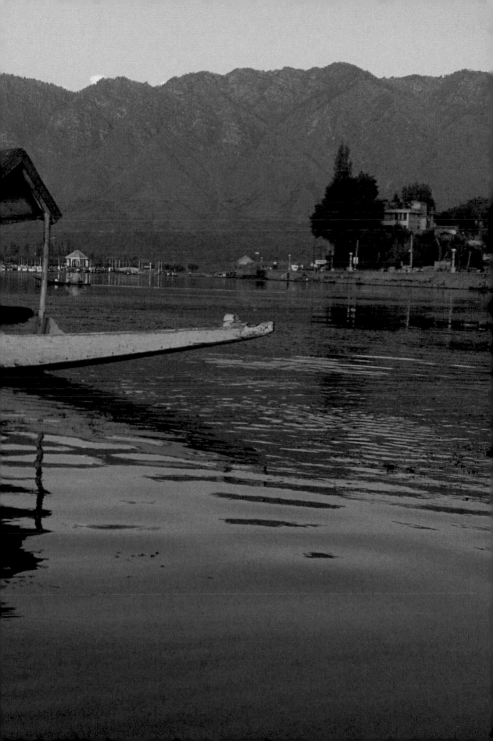

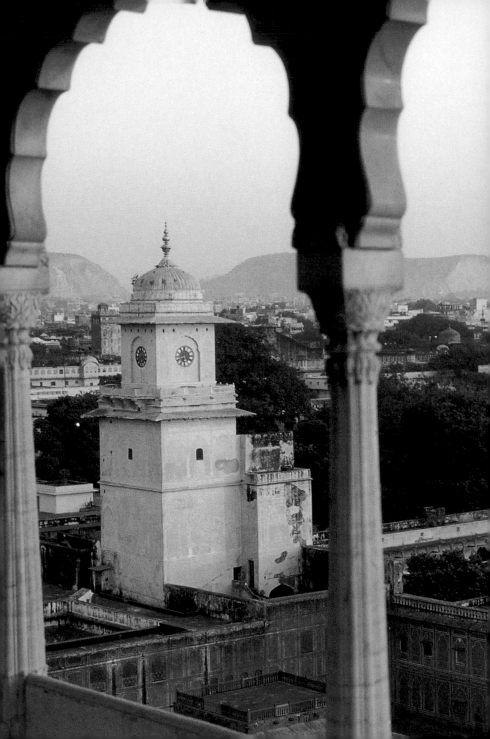

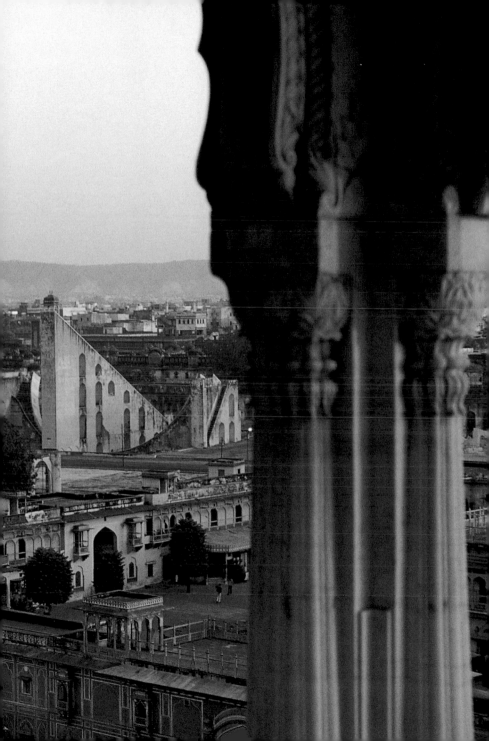

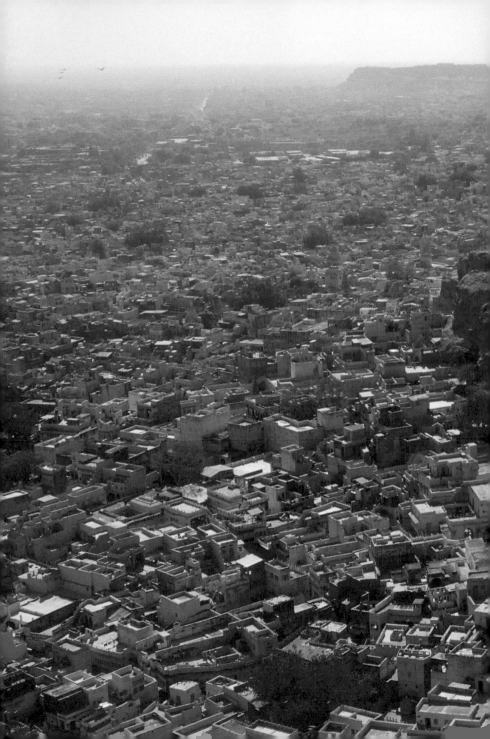

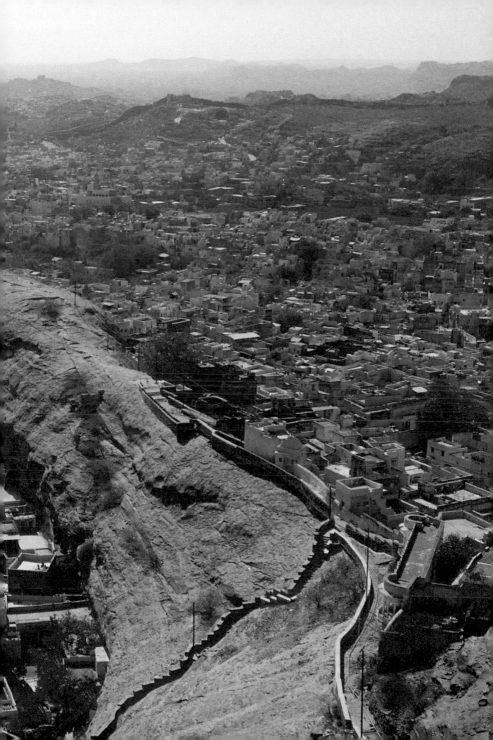

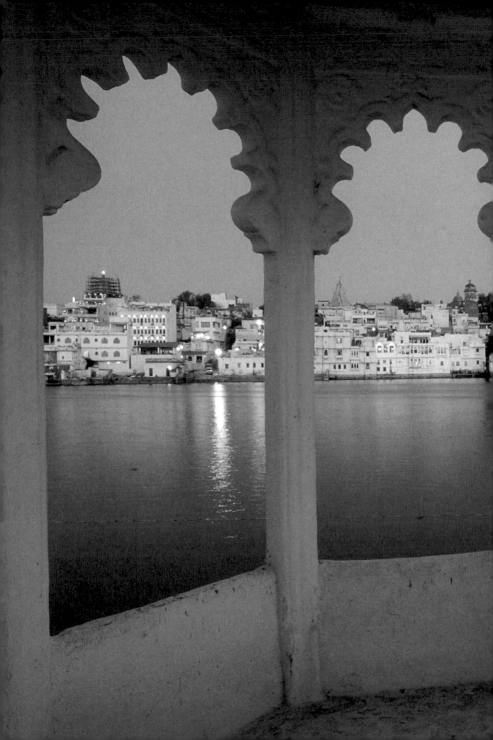

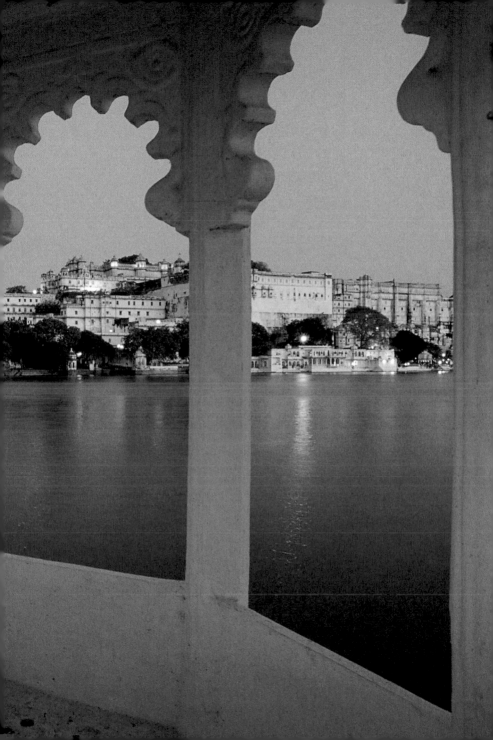

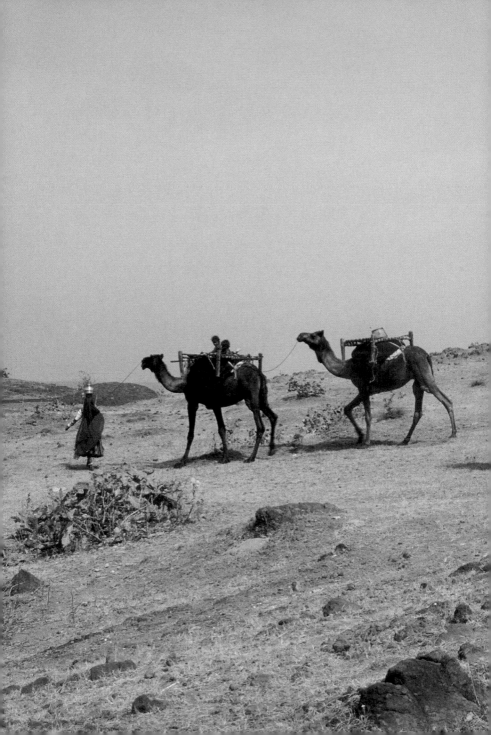

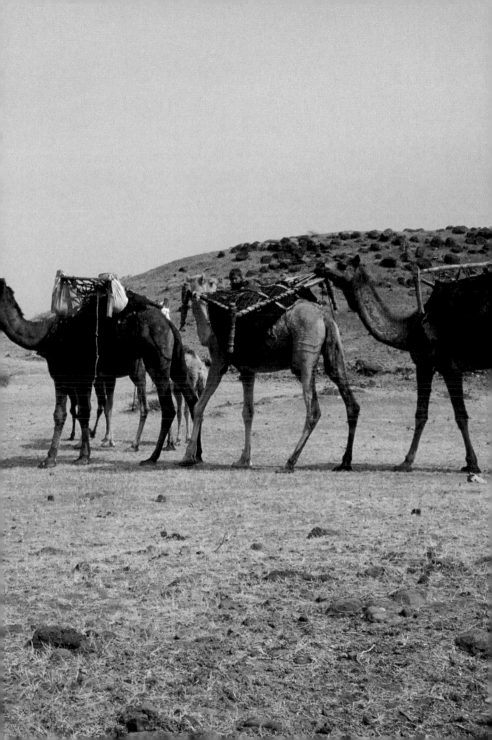

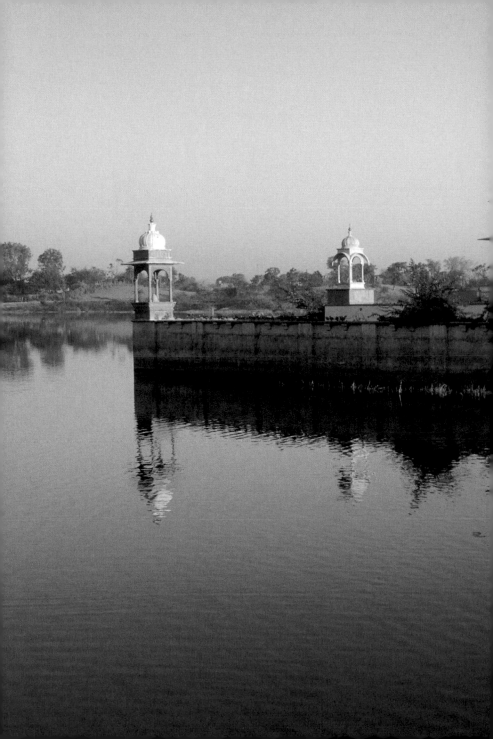

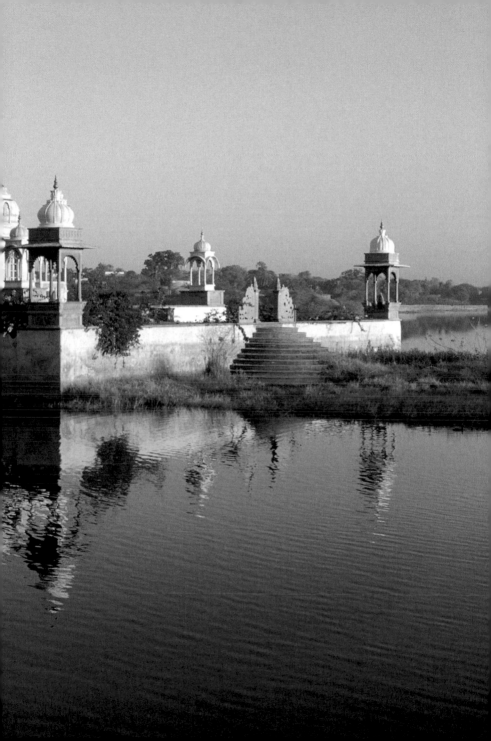

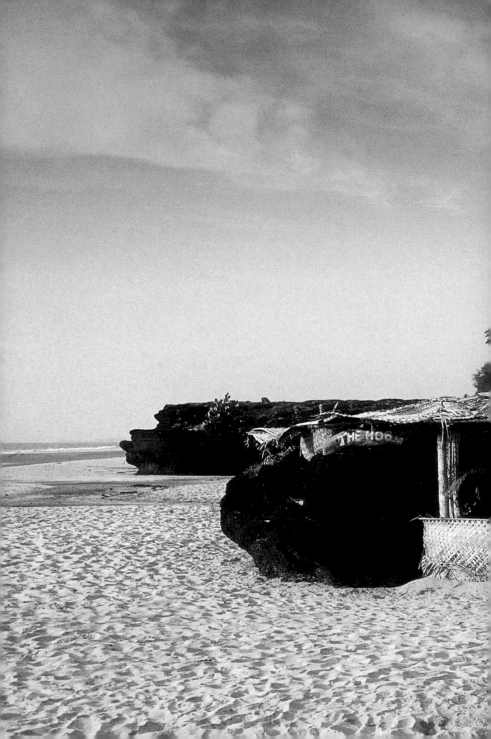

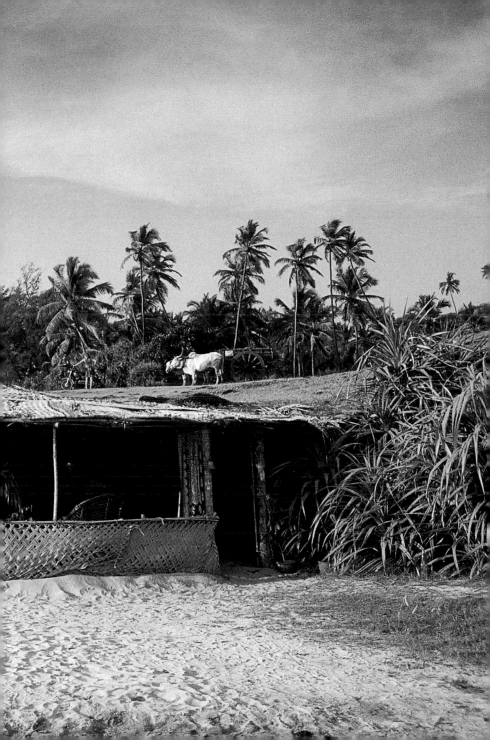

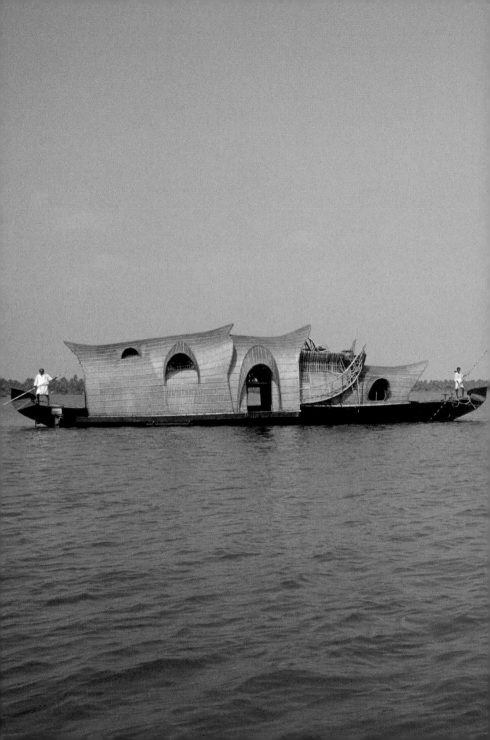

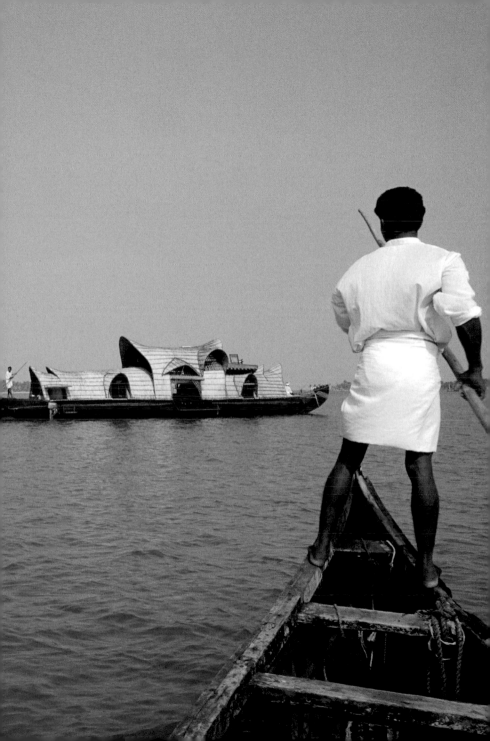

2/3 Gilded fresco in the Juna Mahal, the Old Palace of Dungarpur, Rajasthan. *Fresque dorée au Juna Mahal, le Vieux palais de Dungarpur au Rajasthan.* Goldverziertes Fresko im Alten Palast von Dungarpur in Rajasthan.

4/5 Rabari children in front of a mud hut in the Rann of Kutch, Gujarat. *Des enfants Rabari devant une cabane en boue dans le Rann de Kutch, Gujerat.* Rabari-Kinder vor einer Lehmhütte in der Rann von Kutch in Gujarat.

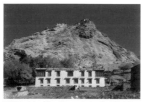

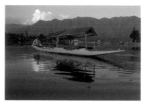

16/17 A traditional house in the Buddhist village of Mulbekh, Ladakh. *Une maison traditionnelle au village bouddhiste Mulbekh dans le Ladakh.* Ein traditionelles Haus in dem buddhistischen Dorf Mulbekh in Ladakh.

18/19 A traditional boat with canopy on a calm lake in Kashmir. *Une embarcation traditionnelle avec baldaquin sur un lac calme du Cachemire.* Ein traditionelles Boot mit Baldachin auf einem ruhigen See in Kaschmir.

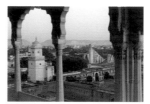

20/21 The houses of Aman Nath and Francis Wacziarg in Neemrana near Delhi. *Les maisons d'Aman Nath et Francis Wacziarg à Neemrana près de Delhi.* Aman Naths und Francis Wacziargs Häuser in Neemrana.

22/23 View from the maharaja's palace over Jaipur, Rajasthan's "Pink City". *Jaipur, la «ville rose» du Rajasthan, vue du palais du maharaja.* Blick aus dem Maharaja-Palast auf Jaipur, die »Pink City« von Rajasthan.

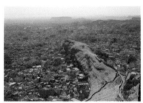

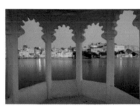

24/25 The blue-washed houses of Jodhpur, known as "Blue City". *Les maisons badigeonnées en bleu de Jodhpur qu'on appelle la «ville bleue».* Die blaugetünchten Häuser von Jodhpur, die auch »Blue City« genannt wird.

26/27 View from Lake Pichola of Udaipur, the tabled "City of Sunrise". *Udaipur, la fameuse «ville du soleil levant», vue du lac Pichola.* Blick vom Pichola-See auf Udaipur, die berühmte »Stadt des Sonnenaufgangs«.

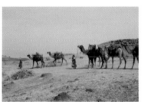

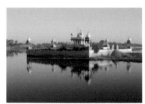

28/29 Rabari nomads in the wasteland of the Rann of Kutch, Gujarat. *Des nomades Rabari sur les terres arides du Rann de Kutch, Gujerat.* Rabari-Nomaden in der Wüstenlandschaft der Rann von Kutch in Gujarat.

30/31 Lake Gaibsagar with a Shiva temple in Dungarpur, Rajasthan. *Le lac Gaibsagar à Dungarpur au Rajasthan avec un temple de Shiva.* Der Gaibsagar-See mit einem Shiva-Tempel in Dungarpur in Rajasthan.

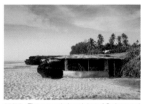

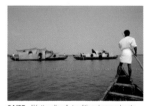

32/33 The romantic beach hut of Graham and Kay Coward-Windsor in Goa. *La cabane romantique de Graham et Kay Coward-Windsor sur la plage de Goa.* Die romantische Hütte von Graham and Kay Coward-Windsor in Goa.

34/35 "Kettuvallam", traditional cargo boats, in the lagoons of Kerala. *Des «Kettuvallam» traditionnels pour le transport des marchandises, dans les lagons du Kerala.* »Kettuvallam«, traditionelle Lastkähne, in den Lagunen von Kerala.

"But the collision of desperate poverty with opulence pomp, and 'barbaric gorgeousnesses' seemed to enhance the fairytale quality of his experience in India."

Mark Twain, *Following the Equator* (1897)

«Mais la collision de la pauvreté-désespérée avec la splendeur opulente et les 'magnificences barbares' semblaient renforcer encore la qualité féerique de l'expérience qu'il avait de l'Inde.»

Mark Twain, *Le tour du monde d'un humoriste* (1897)

»Aber der Zusammenprall von verzweifelter Armut mit opulentem Pomp und die 'barbarischen Großartigkeiten' schienen das märchenhaft anmutende Bild, das er von Indien gewonnen hatte, noch zu verstärken.«

Mark Twain, *Dem Äquator nach* (1897)

HOUSES

Maisons Häuser

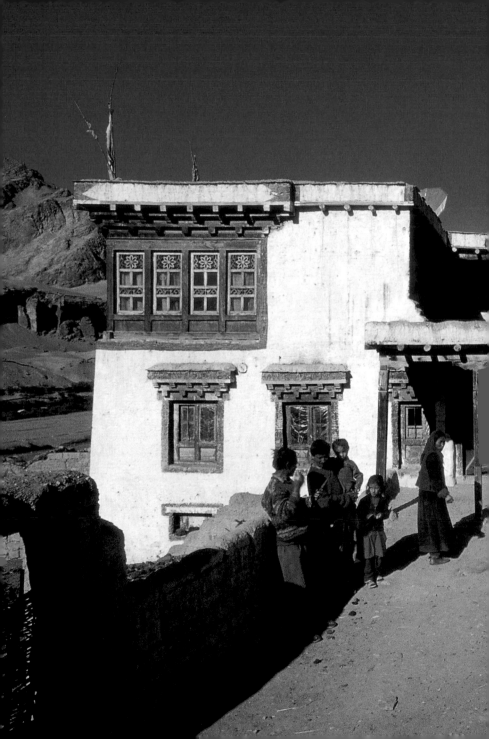

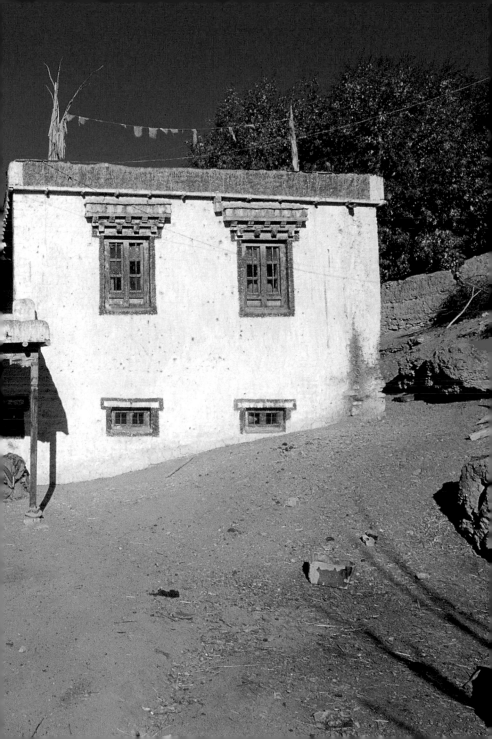

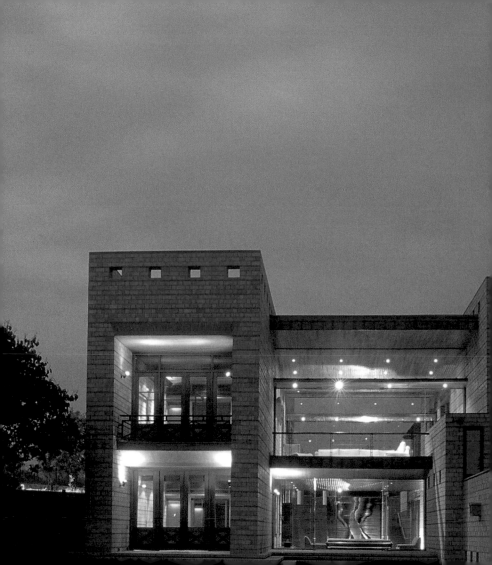

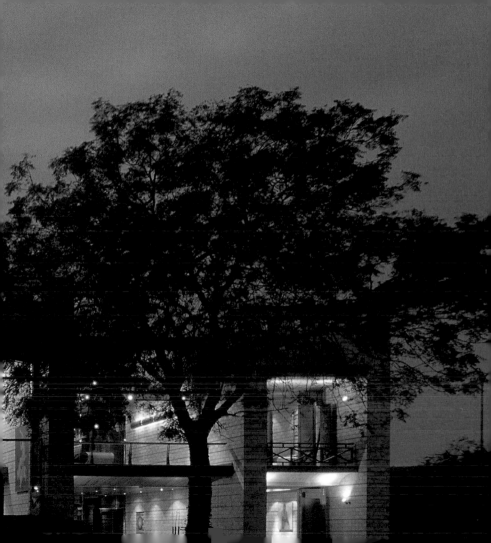

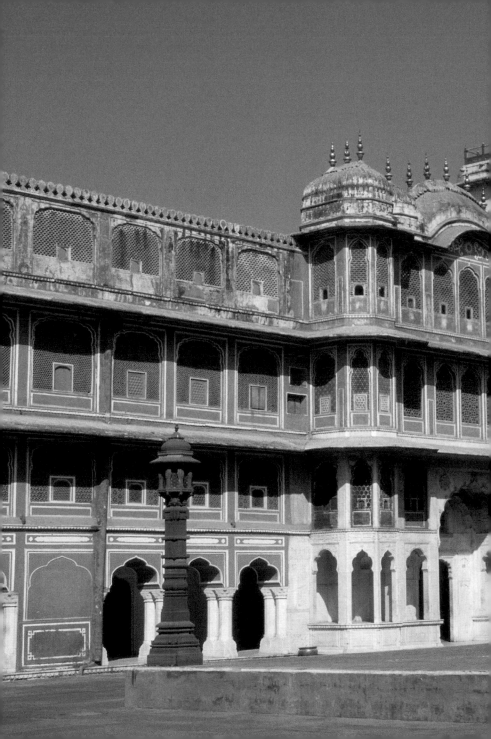

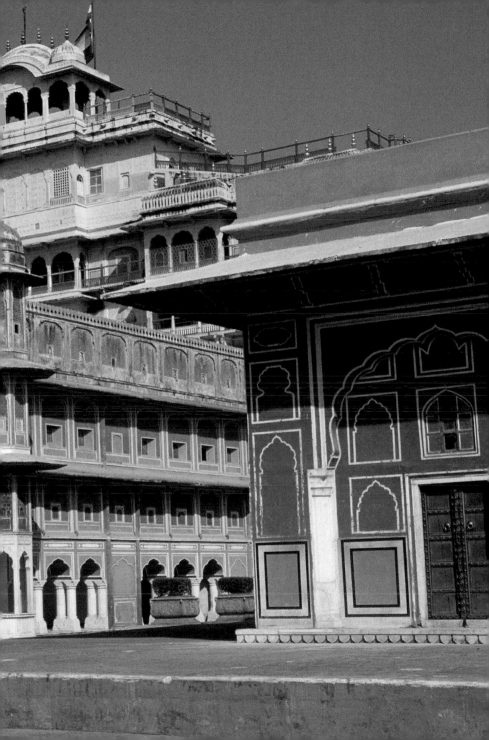

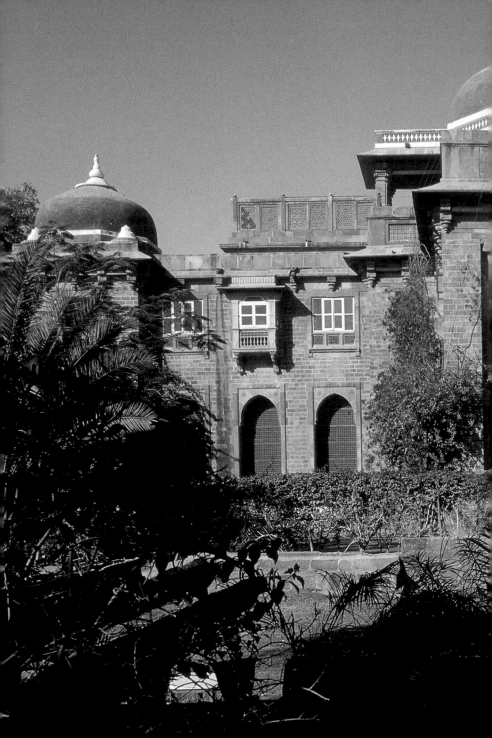

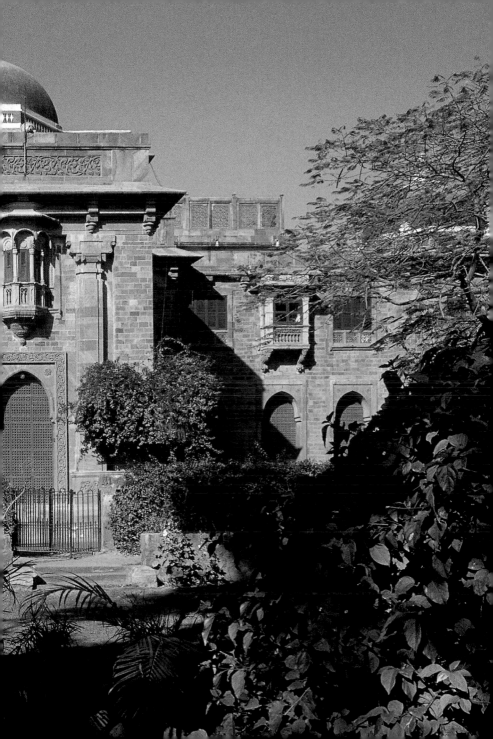

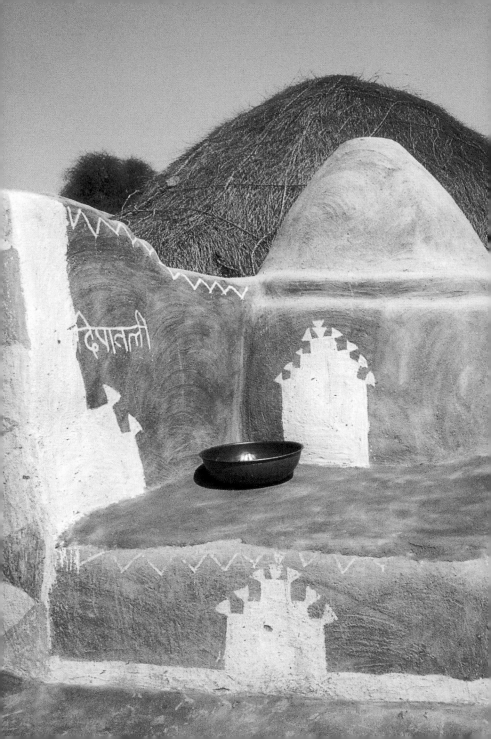

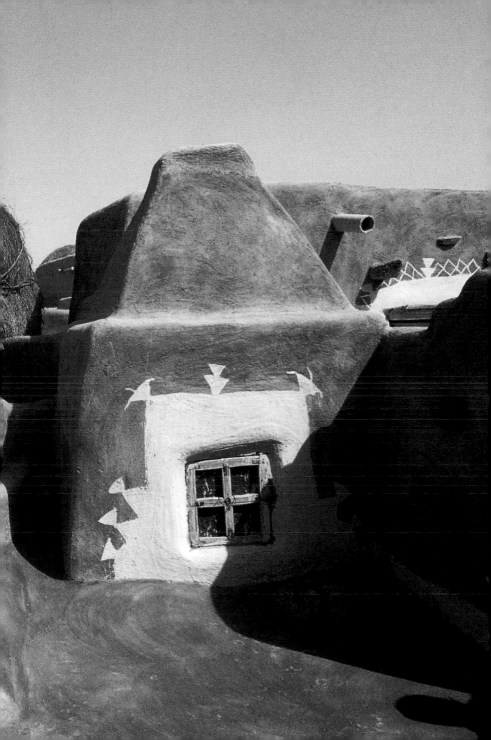

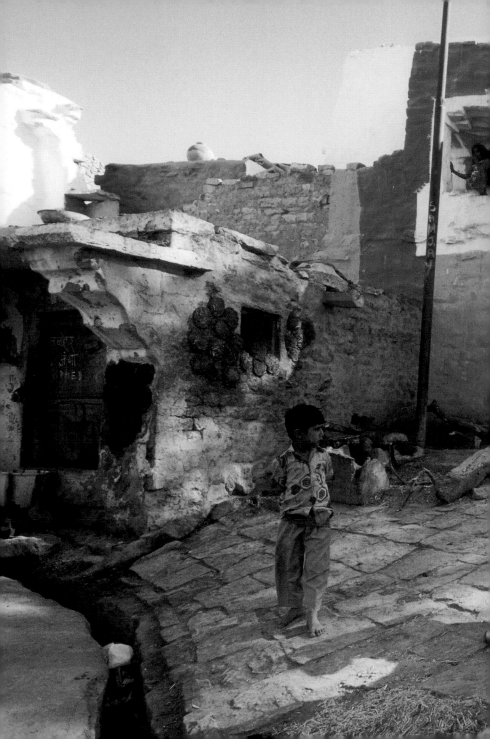

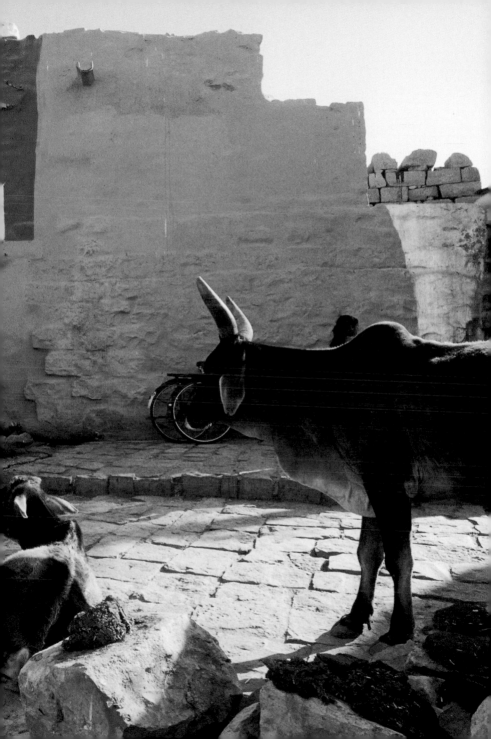

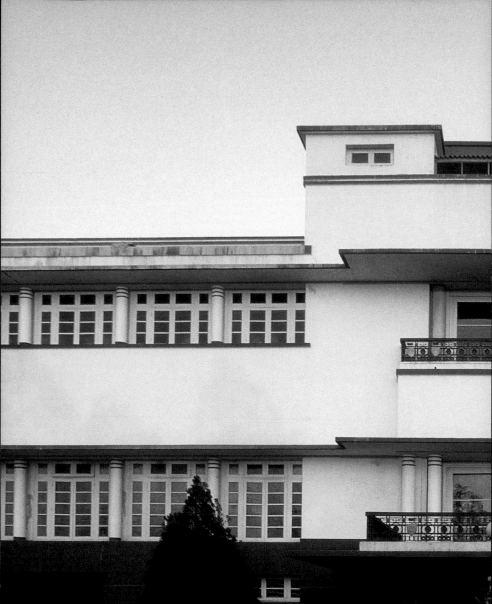

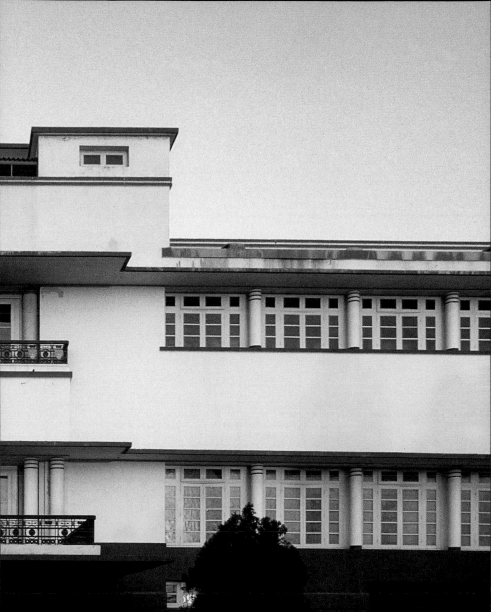

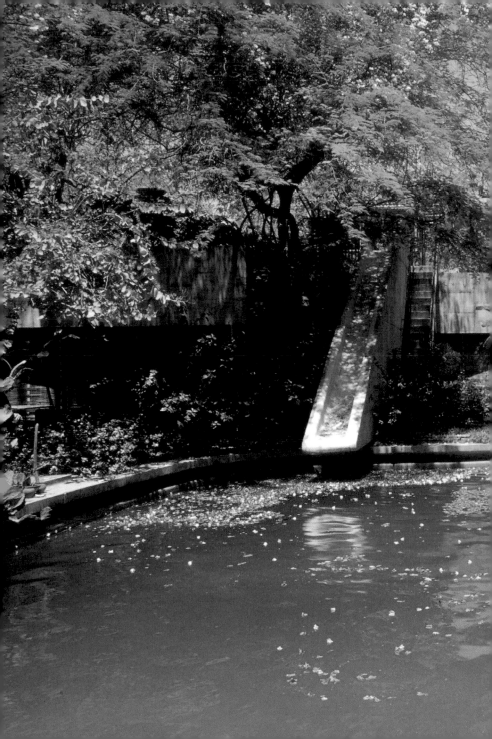

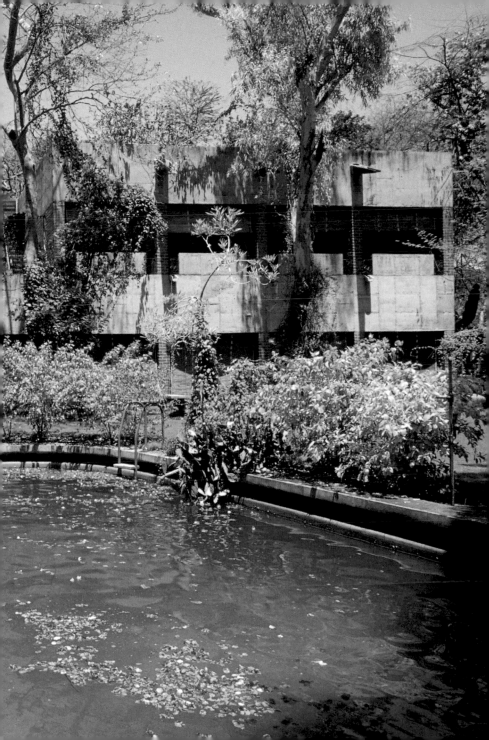

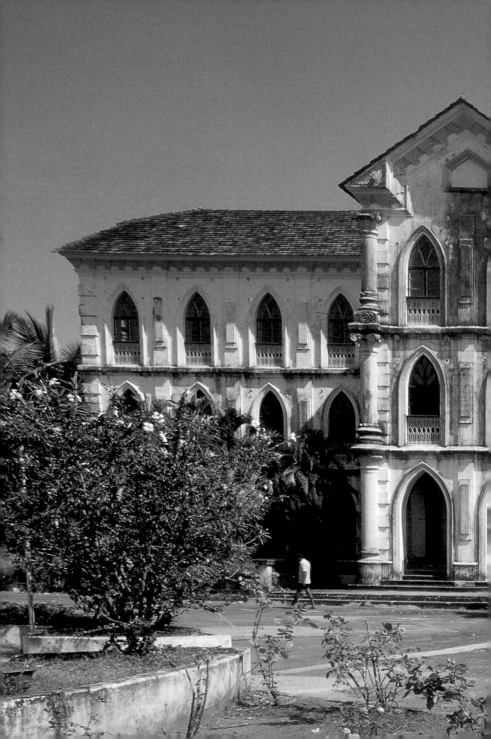

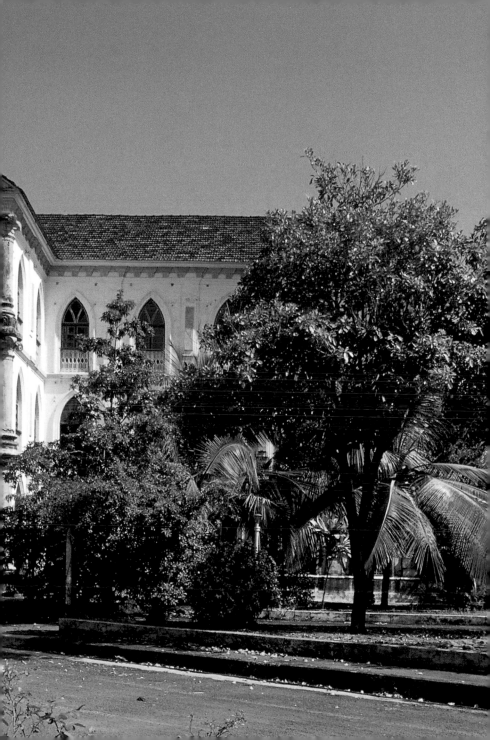

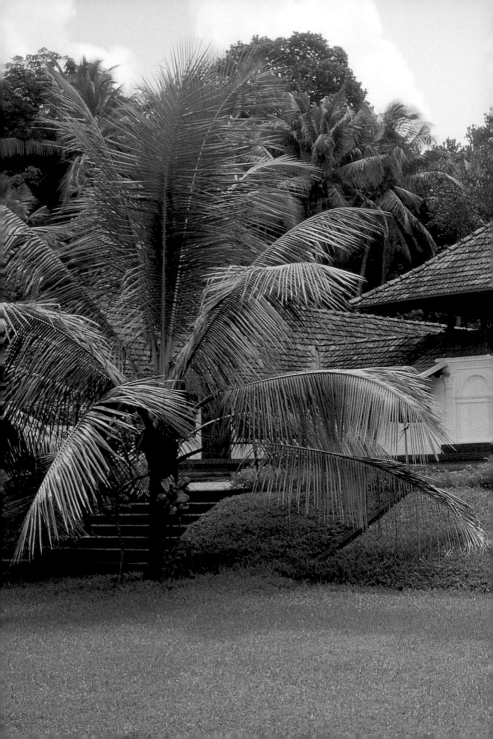

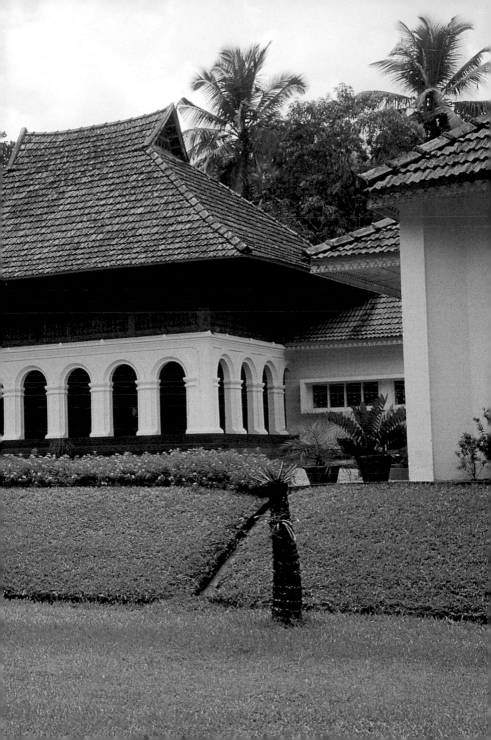

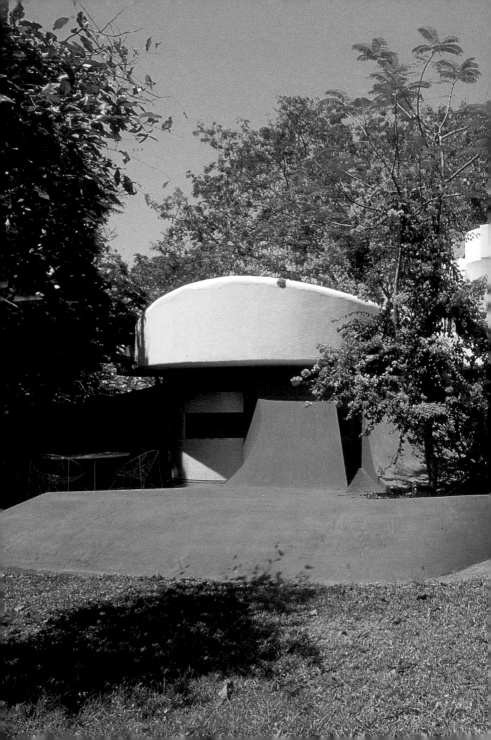

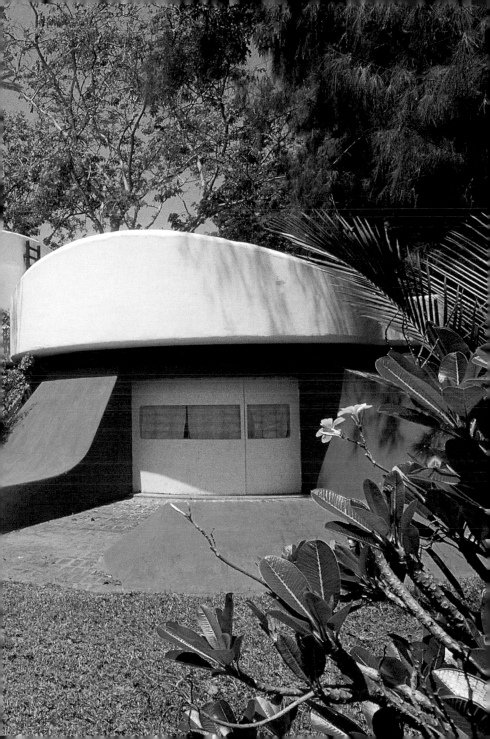

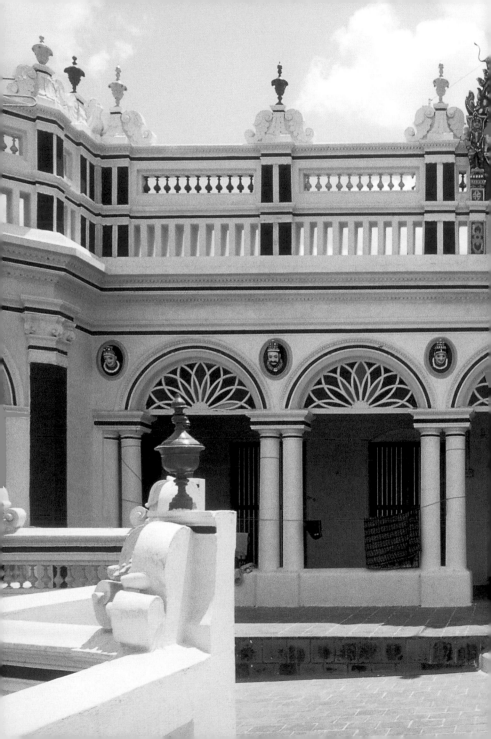

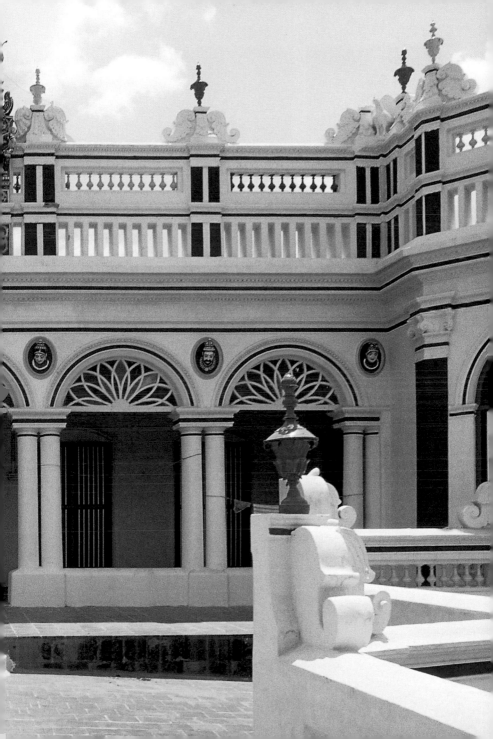

40/41 The houses of Mulbekh are flat-roofed stone-and-wood buildings. *Les maisons de Mulbekh sont en pierre et en bois avec un toit plat.* Die Häuser in Mulbekh verfügen über ein Flachdach und bestehen aus Stein und Holz.

42/43 The postmodern cubic house of Lekha and Ranjan Poddar in Delhi. *La maison cubique post-moderne de Lekha et Ranjan Poddar à Delhi.* Das postmoderne kubische Haus von Lekha und Ranjan Poddar in Delhi.

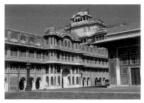

44/45 Hawa Mahal, the "Palace of the Winds", one of Jaipur's landmarks. *Hawa Mahal, le «Palais des Vents», est l'une des attractions de Jaipur.* Hawa Mahal, der »Palast der Winde«, das Wahrzeichen Jaipurs.

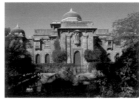

46/47 The sumptuous Ajit Bhawan Palace in Jodhpur was built in 1929. *Le splendide Ajit Bhawan Palace à Jodhpur a été érigé en 1929.* Der prachtvolle Ajit Bhawan Palace in Jodhpur wurde 1929 errichtet.

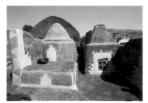

48/49 The traditional hut of a camel-herder in Jaisalmer, in the Thar Desert. *La cabane traditionnelle d'un chamelier à Jaisalmer dans le désert de Thar.* Die traditionelle Hütte eines Kameltreibers in Jaisalmer in der Wüste Thar.

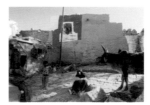

50/51 In the remote desert town of Jaisalmer. *A Jaisalmer, ville isolée du désert.* In der entlegenen Wüstenstadt Jaisalmer.

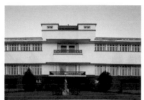

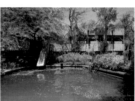

52/53 The superb art deco palace of Morvi, Gujarat. *Le superbe palais Art Déco de Morvi dans le Gujerat.* Der herrliche Art-déco-Palast von Morvi in Gujarat.

54/55 Le Corbusier designed a villa in 1953 for Manorama Sarabhai in Ahmedabad. *Le Corbusier construisit en 1953 une villa à Ahmedabad pour Manorama Sarabhai.* Le Corbusier entwarf 1953 für Manorama Sarabhai eine Villa in Ahmedabad.

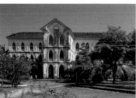

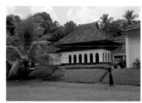

56/57 The palace of the Viscount of Pernem in Goa dates back to the 17th century. *Le palais du vicomte de Pernem à Goa date du 17ᵉ siècle.* Der Palast des Viscomte von Pernem in Goa stammt aus dem 17. Jahrhundert.

58/59 M. J. Kuruvinakunnel's wood house on the Malabar coast, Kerala. *La maison en bois de M. J. Kuruvinakunnel sur la côte de Malabar, Kerala.* Das Holzhaus von M. J. Kuruvinakunnel an der Malabar-Küste in Kerala.

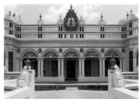

60/61 The house of Christine Devin in Auroville on the Coromandel coast. *La maison de Christine Devin à Auroville sur la côte de Coromandel.* Das Haus von Christine Devin in Auroville an der Koromandelküste.

62/63 Chettinad Palace was built in 1912 near Karaikudi, Tamil Nadu. *Chettinad Palace a été construit en 1912 près de Karaikudi au Tamil Nadu.* Chettinad Palace wurde 1912 bei Karaikudi in Tamil Nadu erbaut.

"The traditional Indian interior has always been floor-orientated as in Japan. Western furniture is an acquired taste in India. (...) But there is scarcely an Indian today, no matter how Western-educated or widely travelled, who is not perfectly comfortable sitting cross-legged on a floor or even sleeping on it in a pinch, and rising the next morning with no ill effects."

James Ivory, film director

«L'intérieur traditionnel indien a toujours été orienté vers le sol, comme au Japon. Certes, les Indiens ont pris goût aux meubles européens. (...) Cependant, il n'est guère d'Indien de nos jours, peu importe qu'il ait vécu en Europe ou non, qu'il ait beaucoup voyagé ou non, qui ne se sente bien assis en tailleur à même le sol ou encore, qui ne puisse dormir par terre s'il le faut et se lever le lendemain matin sans ressentir la moindre gêne.»

James Ivory, cinéaste

»Der traditionelle indische Wohnraum ist immer auf den Fußboden ausgerichtet gewesen, wie das auch für Japan gilt. Die europäische Einrichtung hat sich Indien angeeignet. (...) Dennoch gibt es heute kaum einen Inder, egal ob er nach westlichen Maßstäben erzogen oder viel gereist ist, der sich nicht im Schneidersitz auf dem Boden sitzend wohl fühlt oder sogar im Notfall auf dem Fußboden schlafen kann und am nächsten Morgen aufsteht, ohne jede üble Nachwirkung.«

James Ivory, Regisseur

INTERIORS

Intérieurs Interieurs

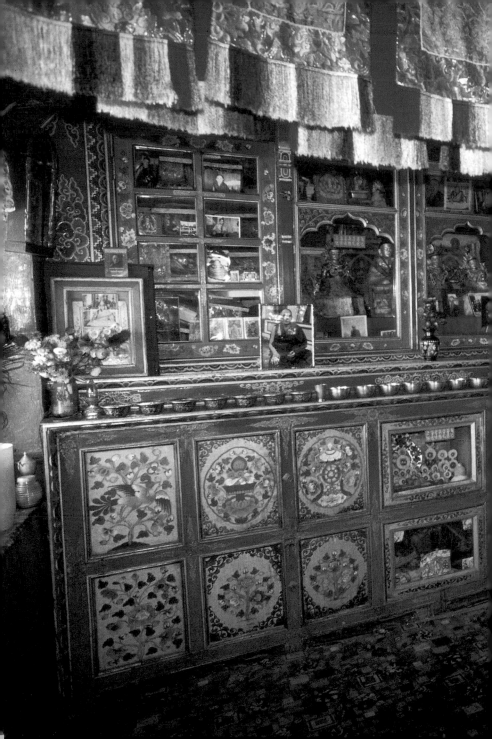

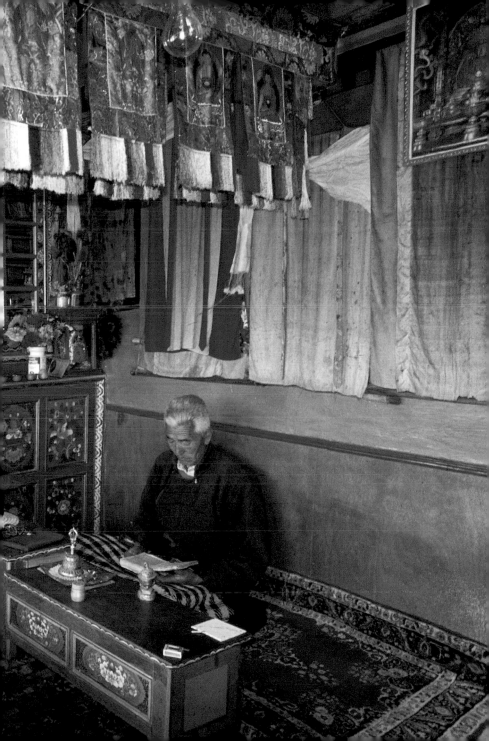

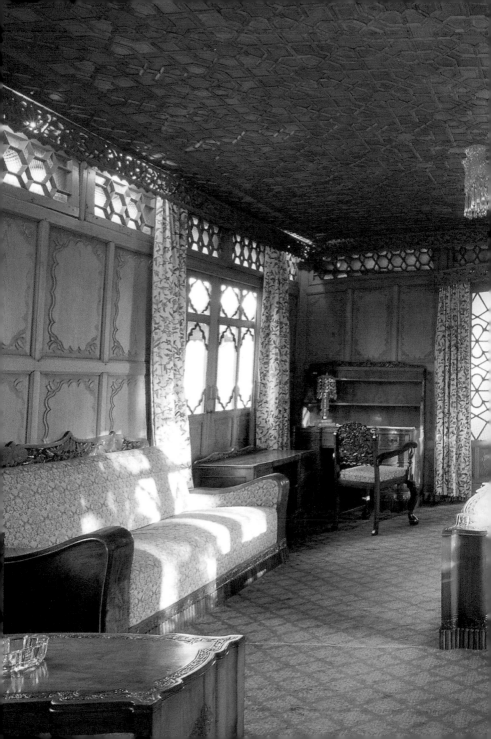

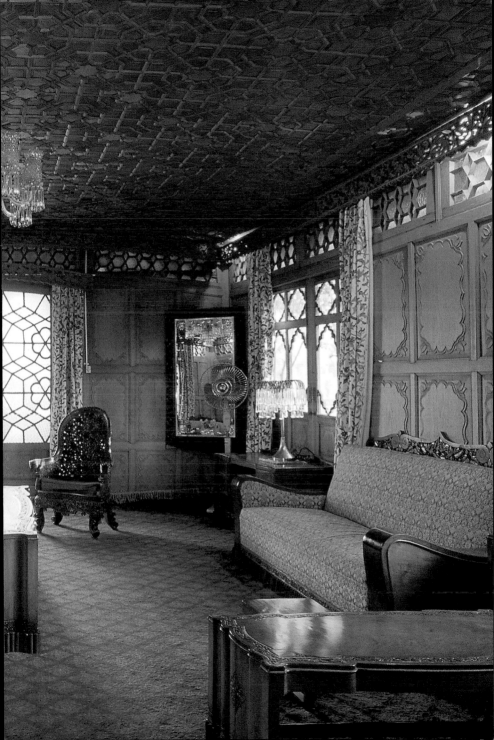

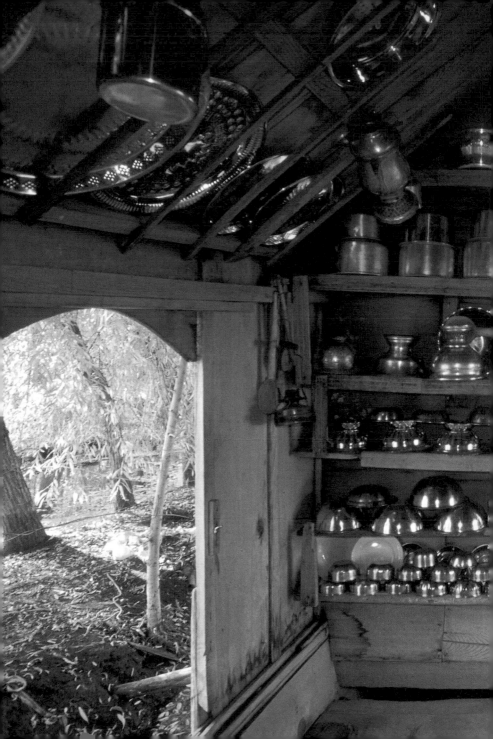

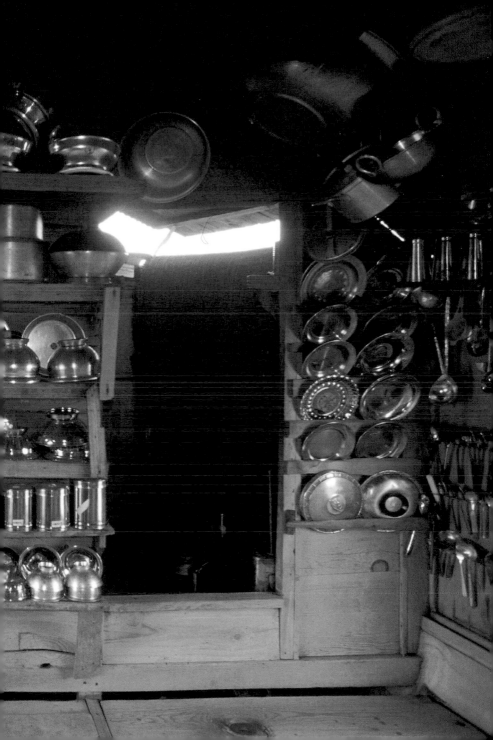

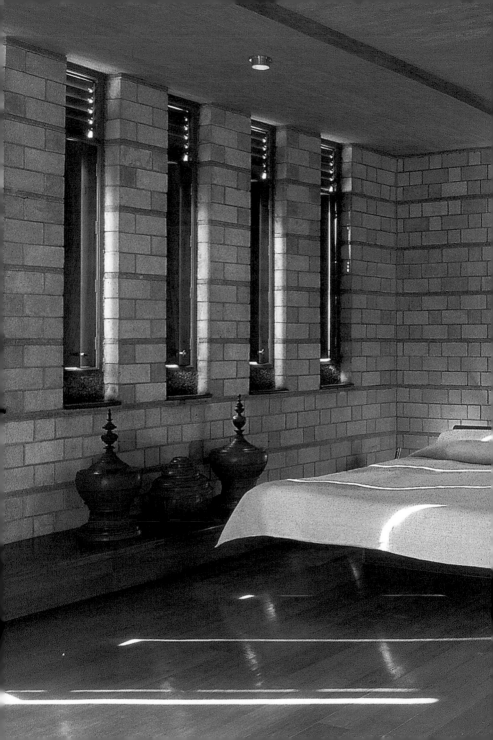

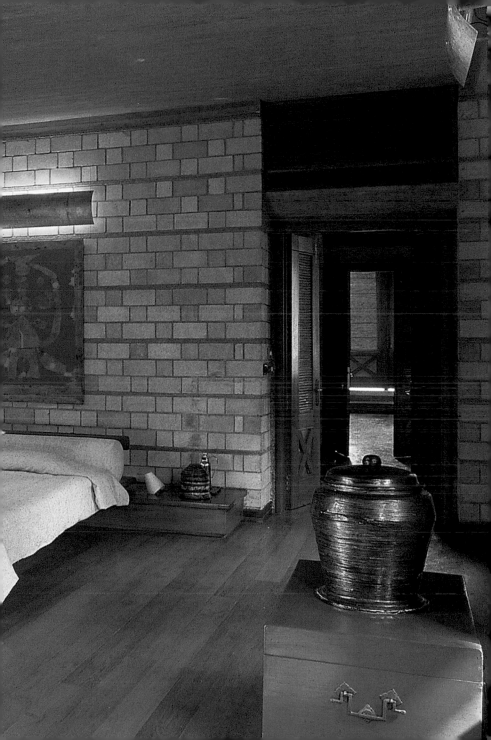

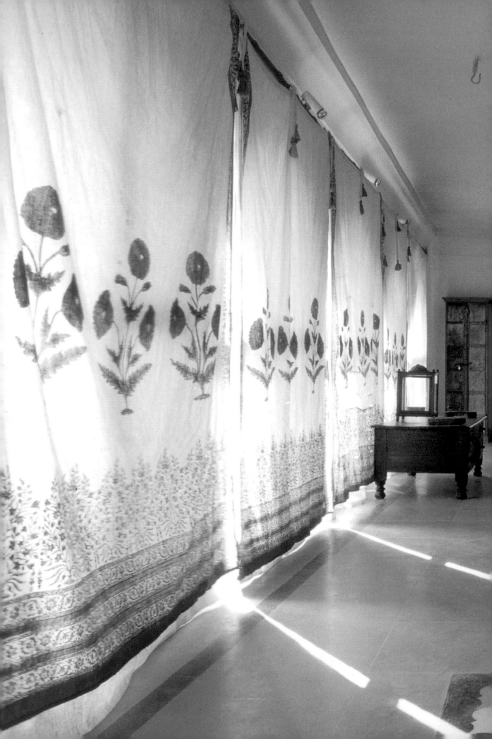

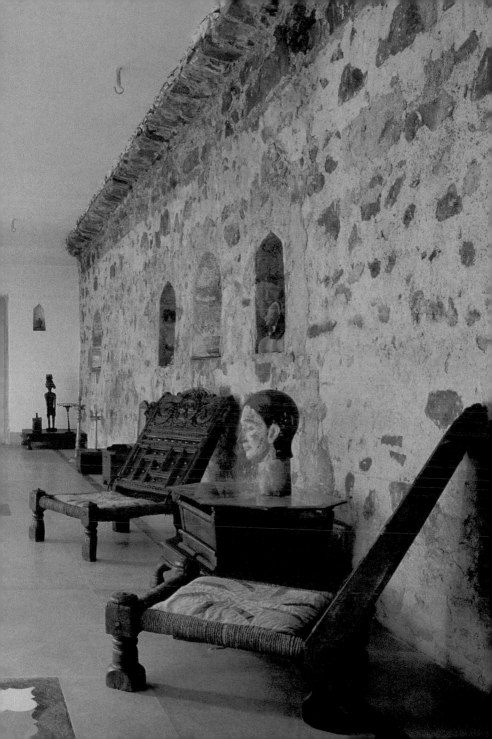

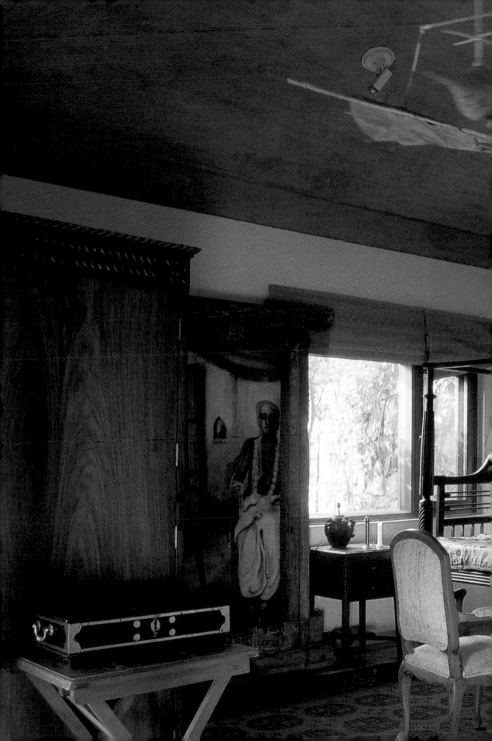

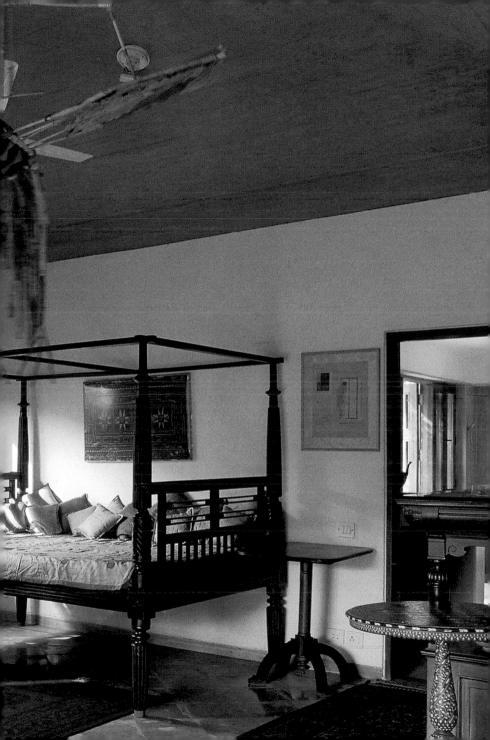

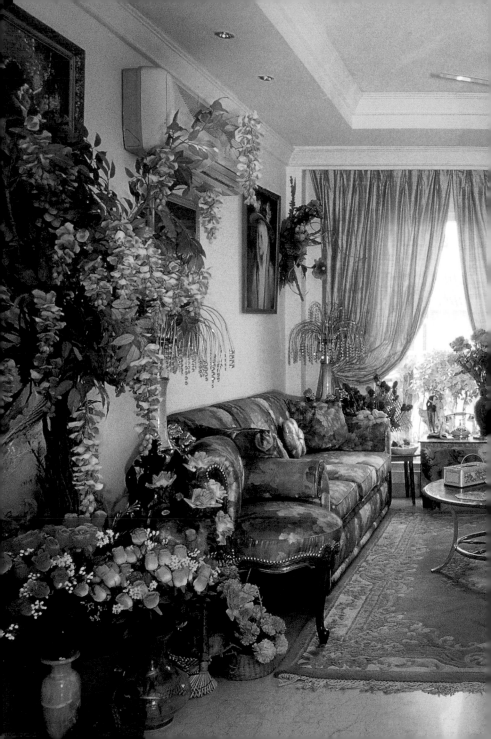

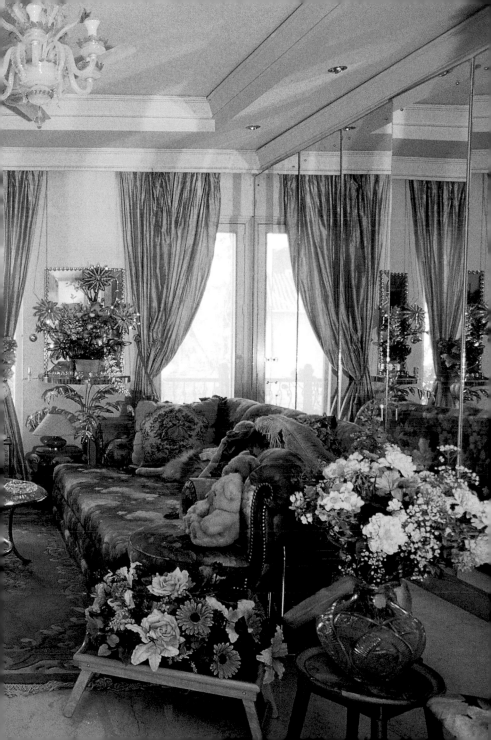

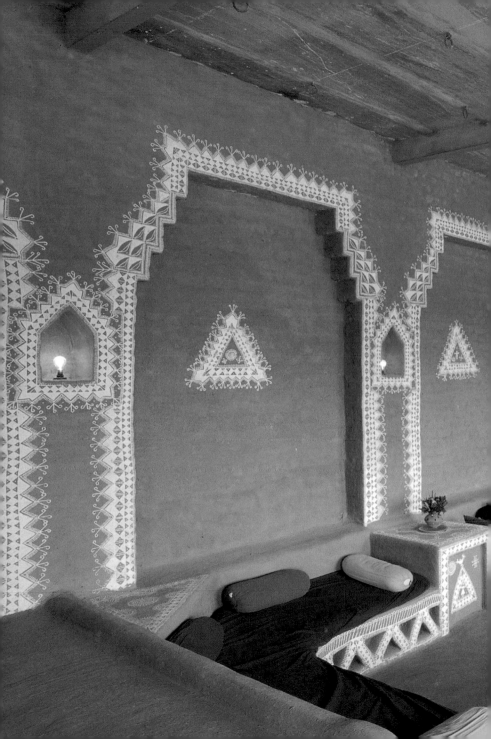

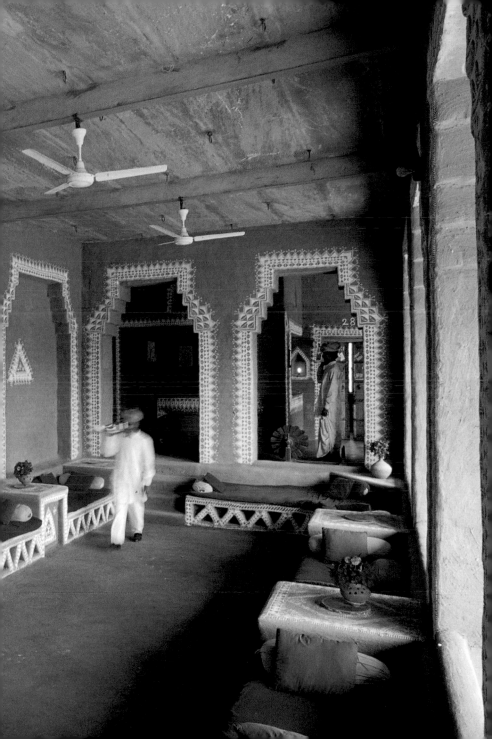

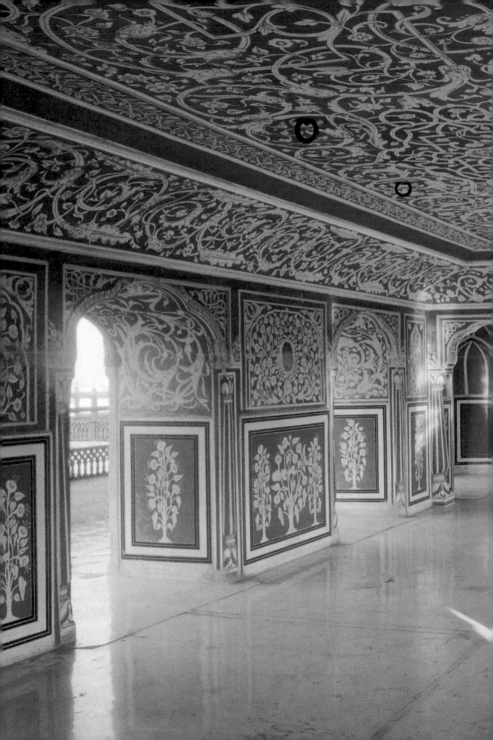

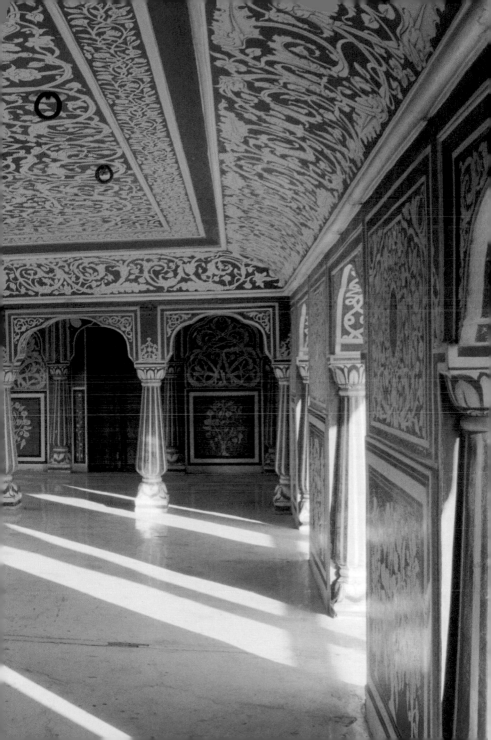

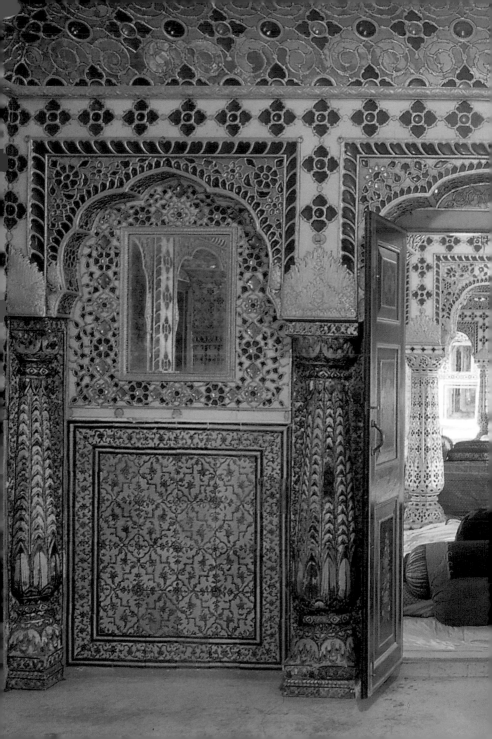

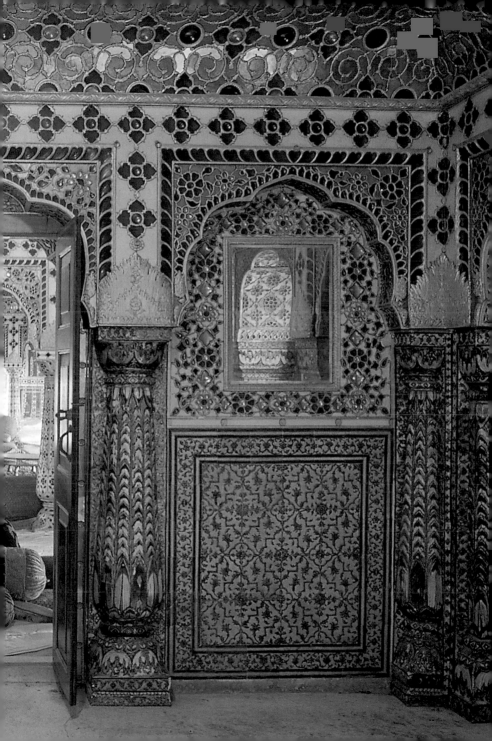

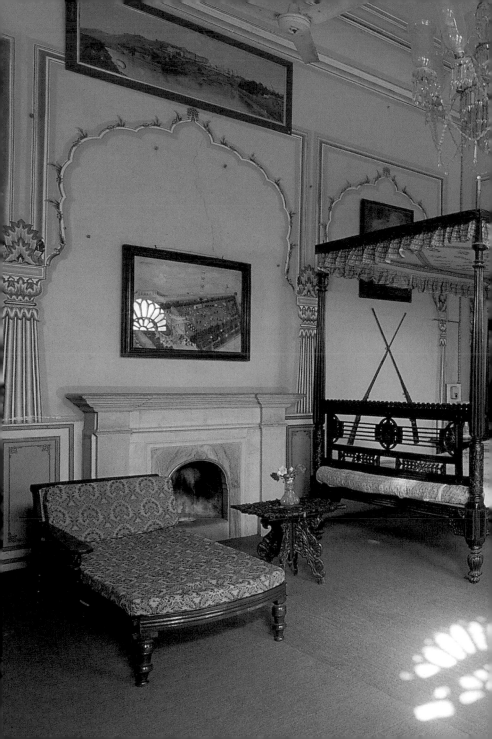

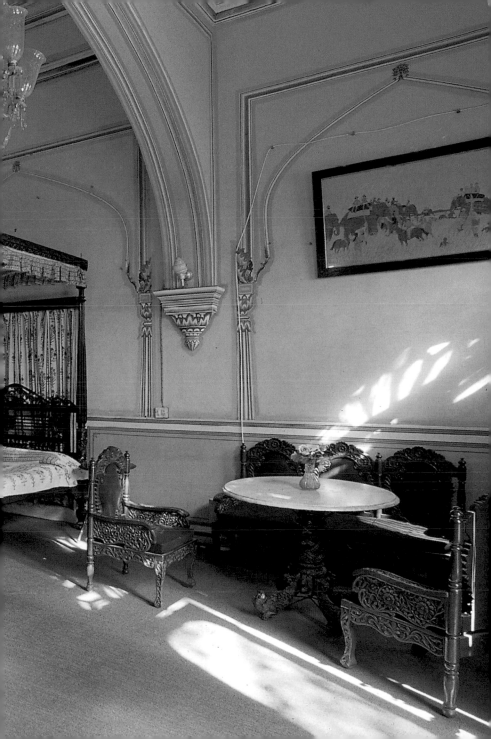

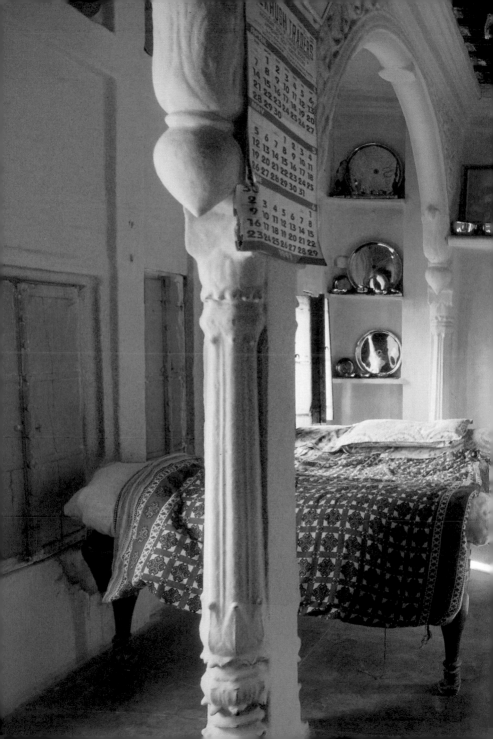

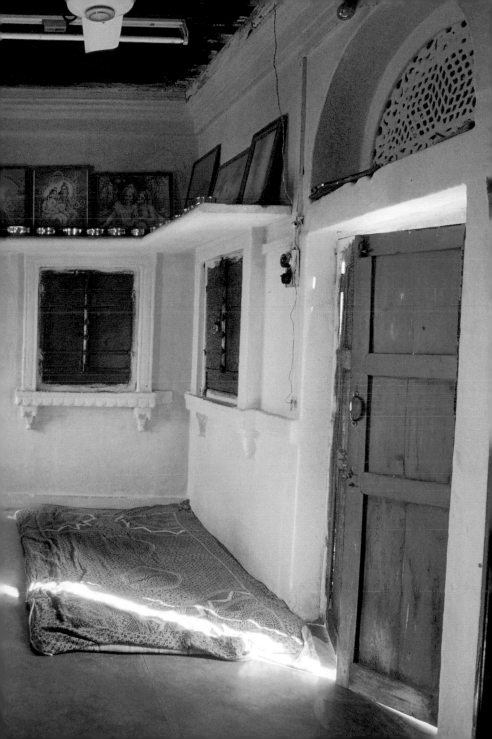

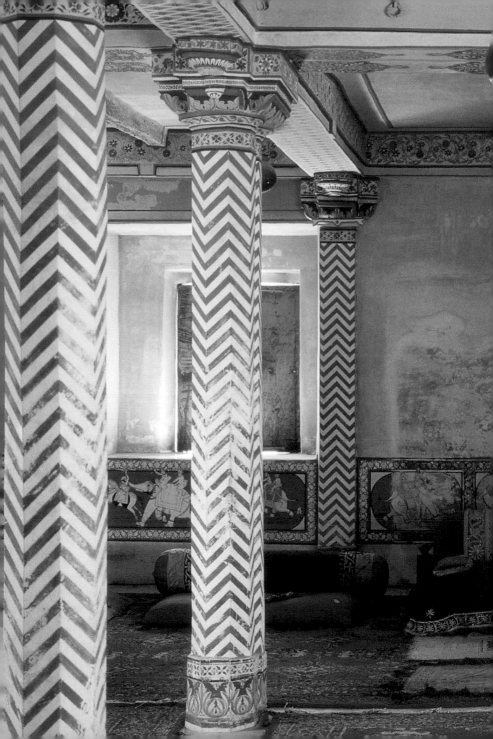

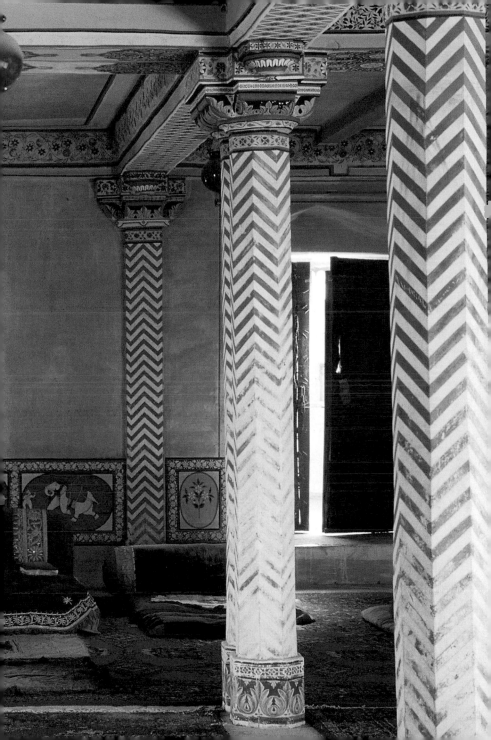

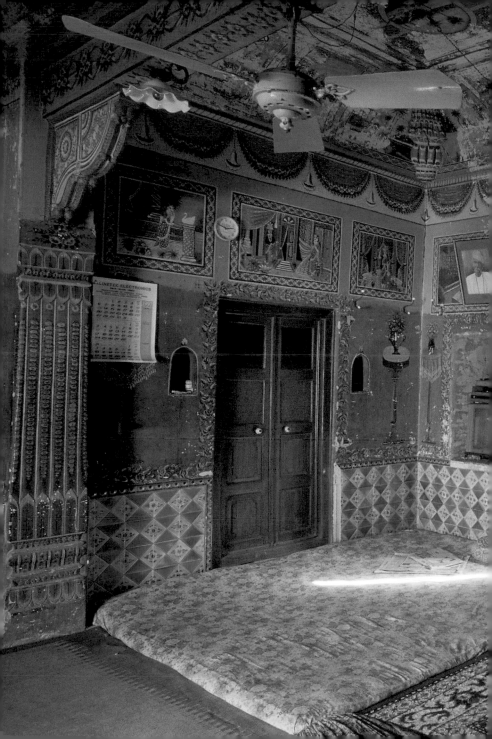

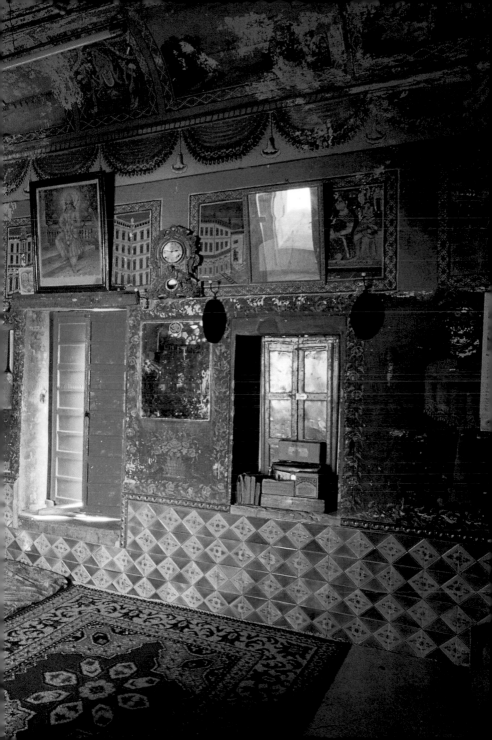

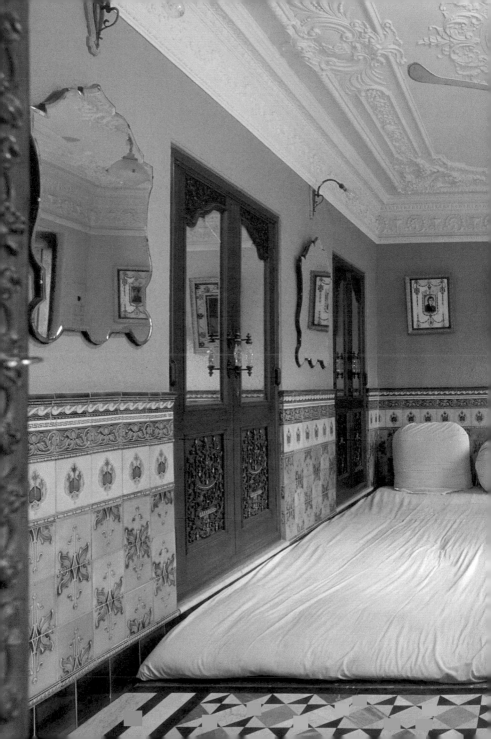

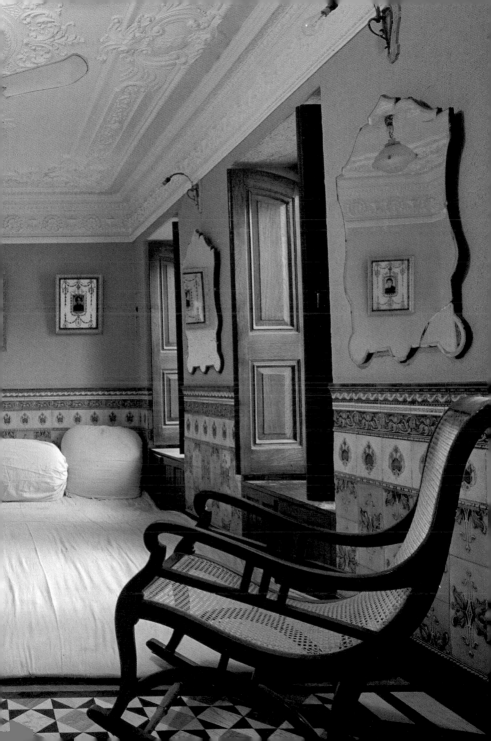

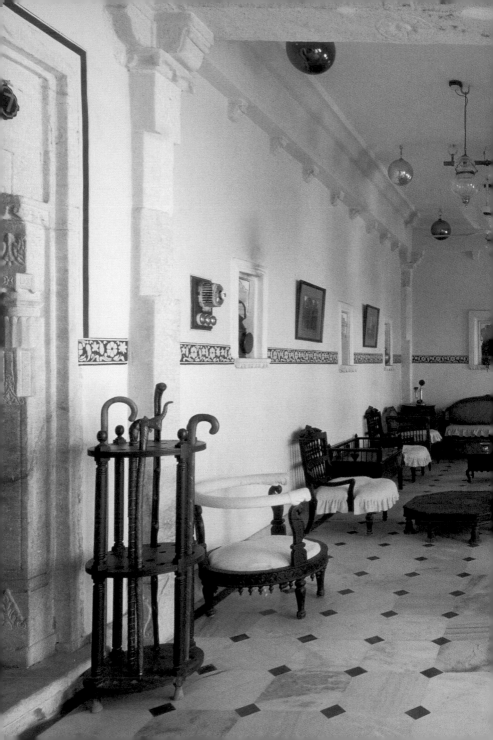

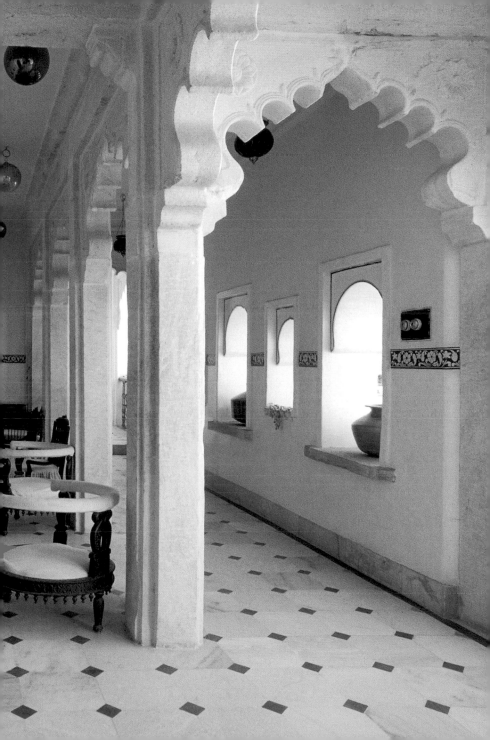

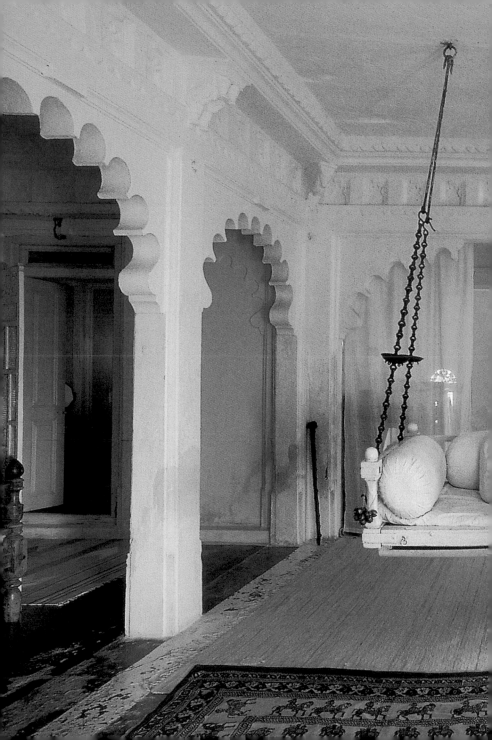

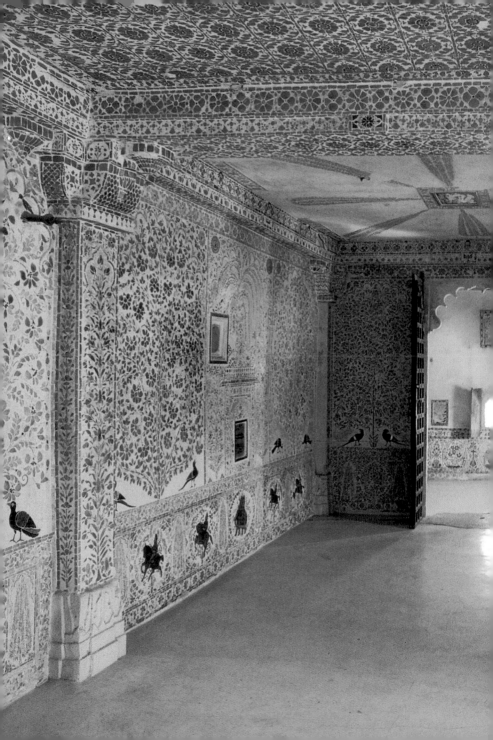

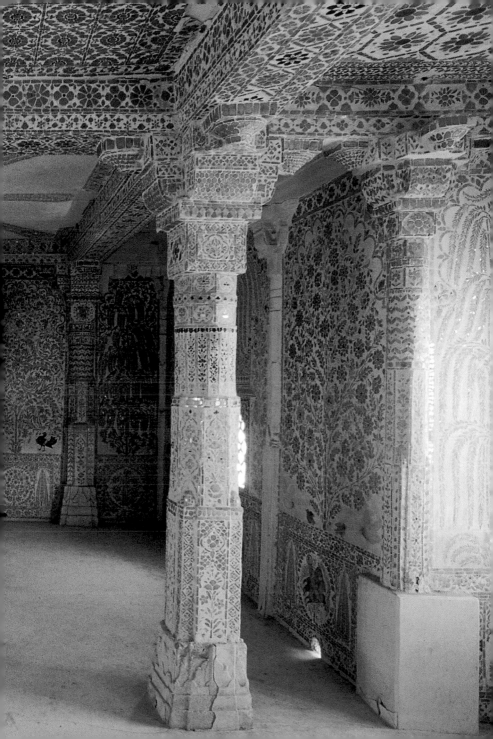

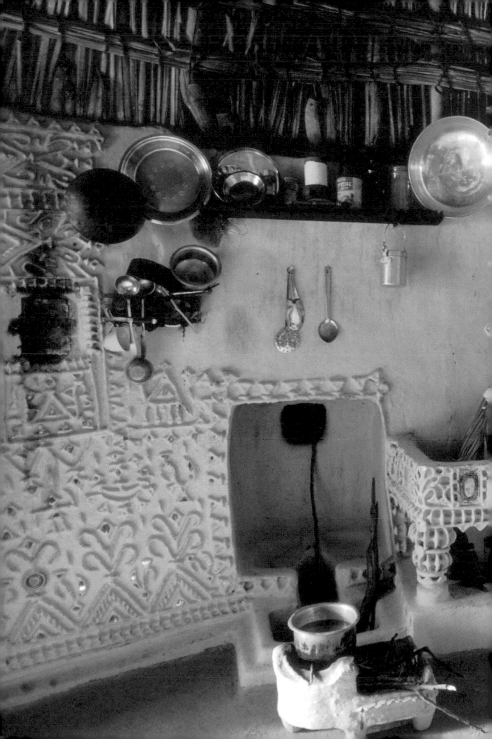

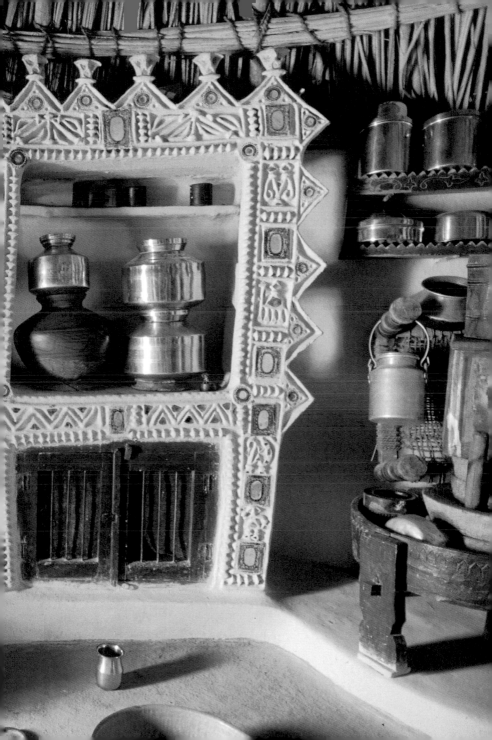

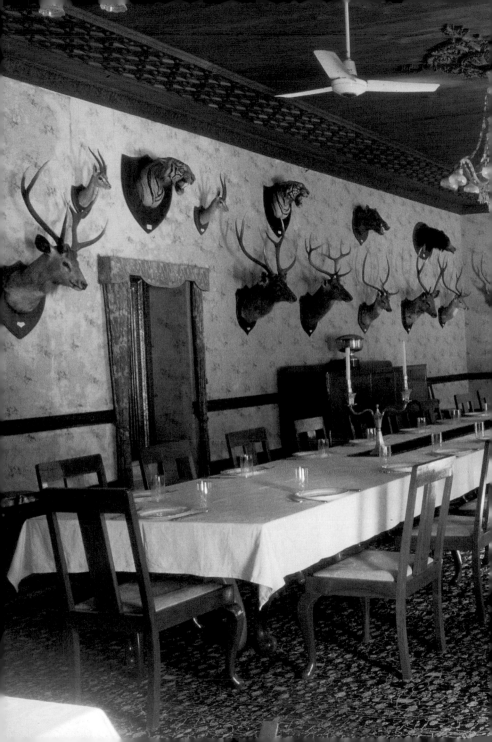

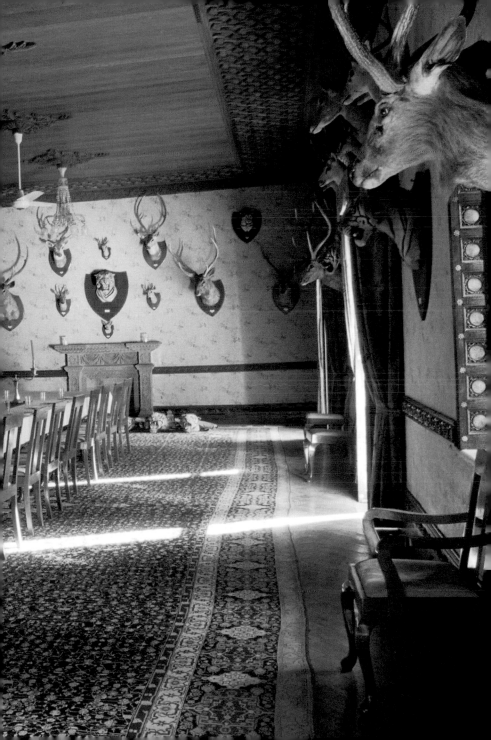

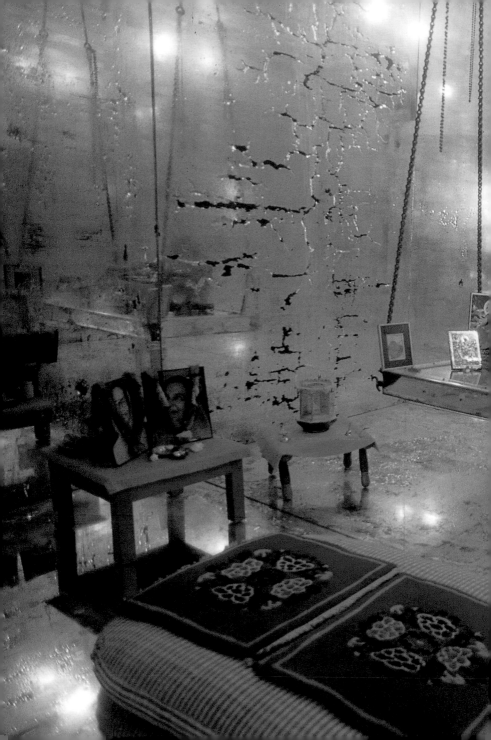

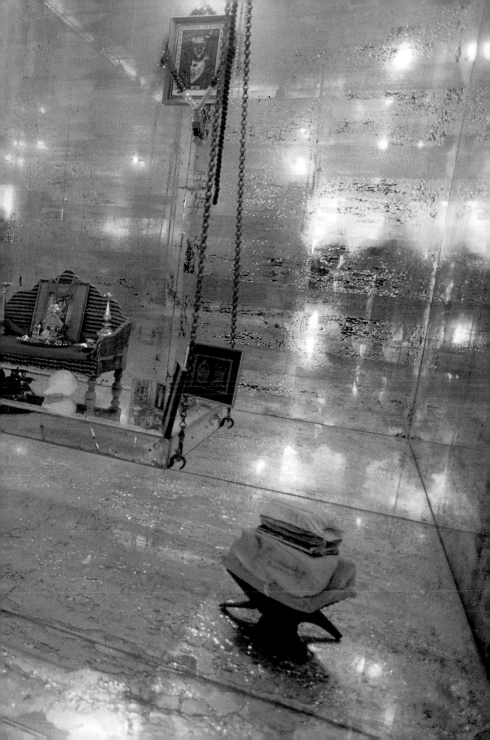

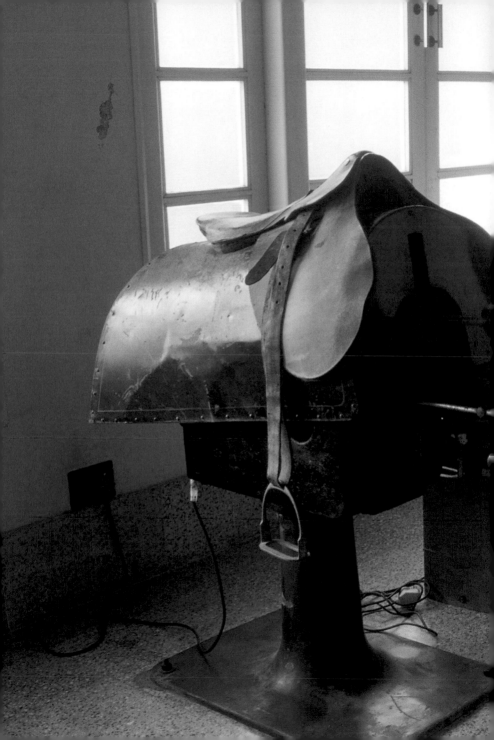

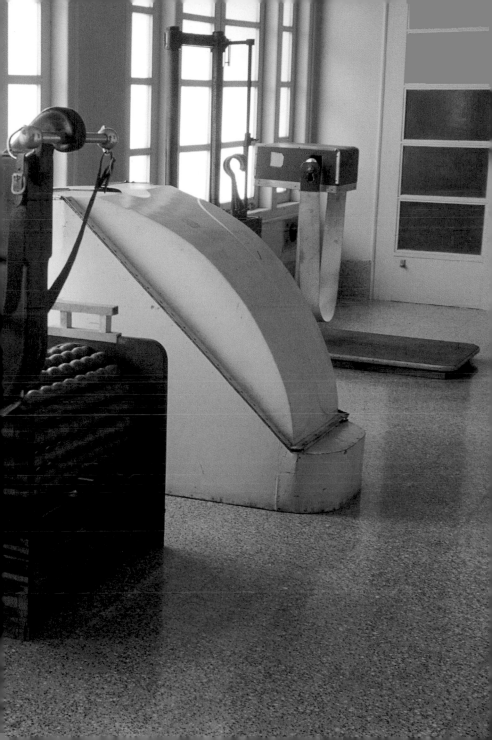

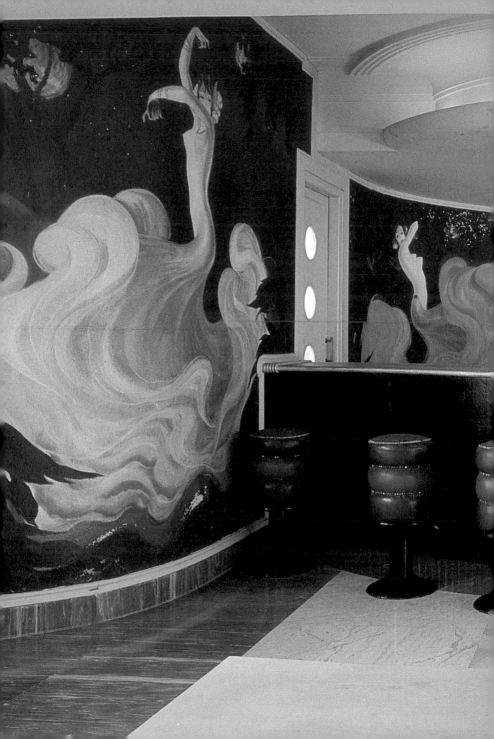

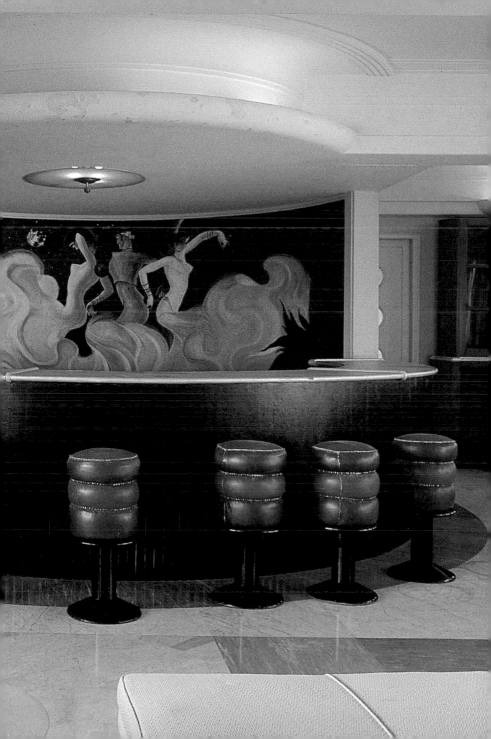

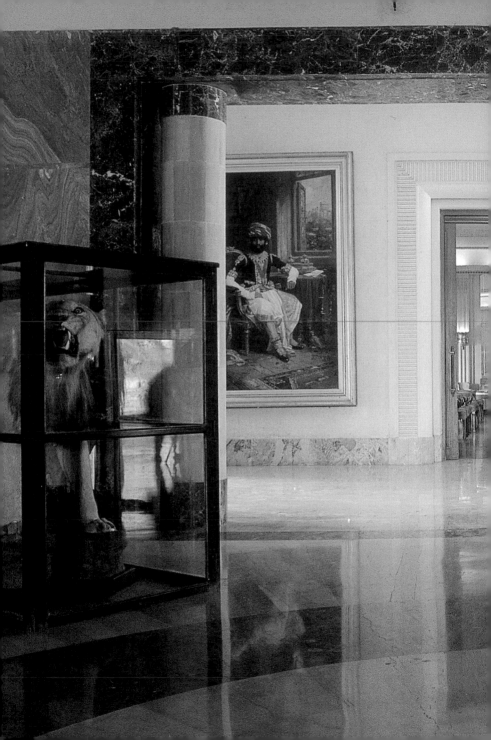

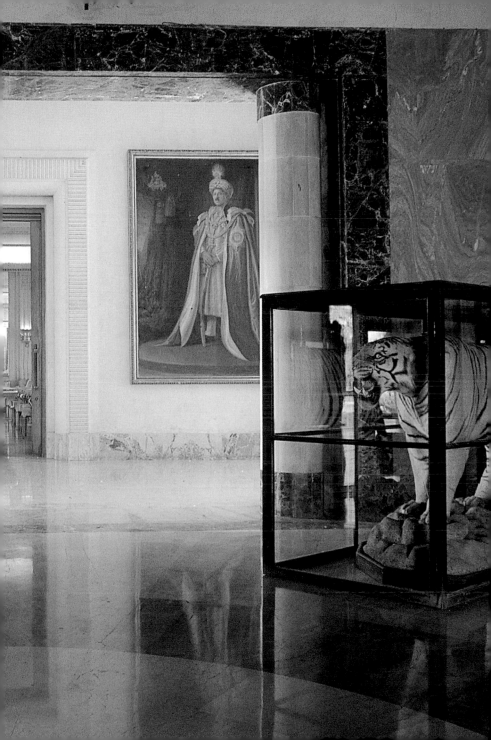

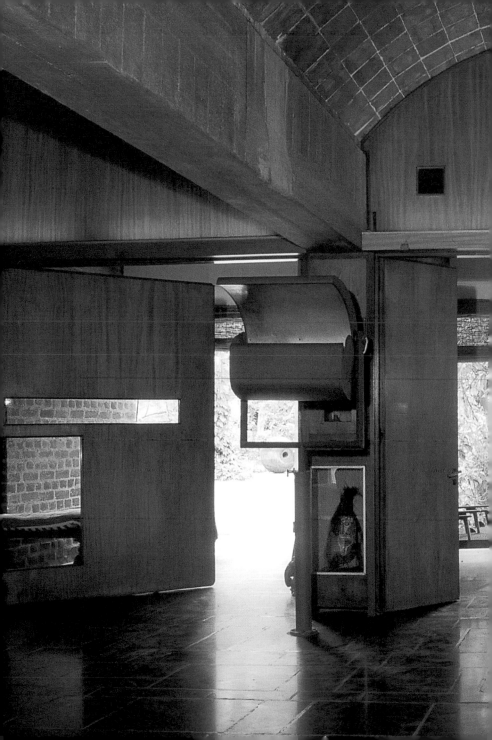

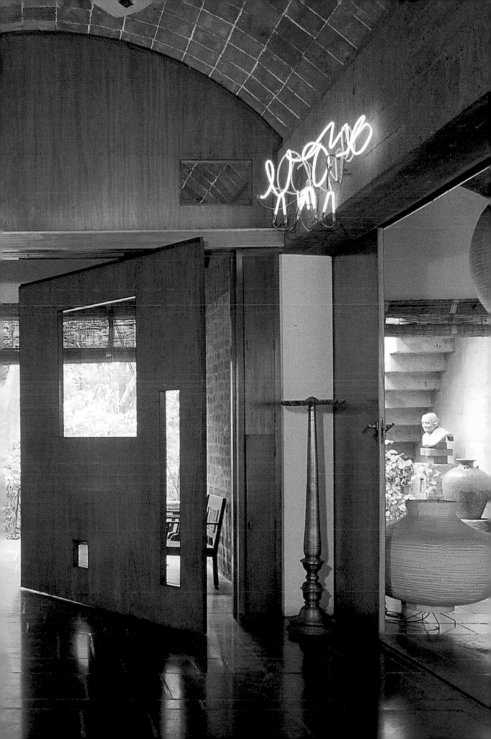

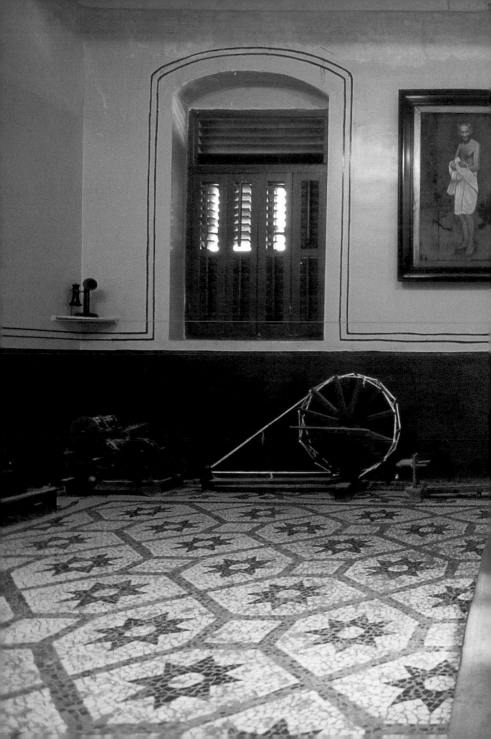

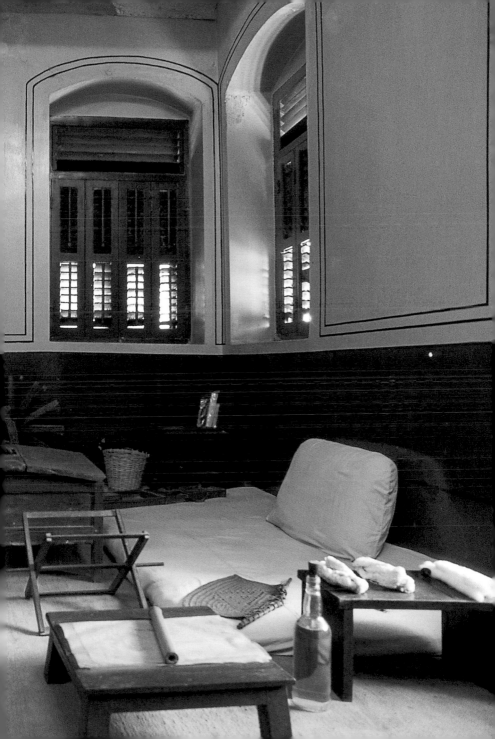

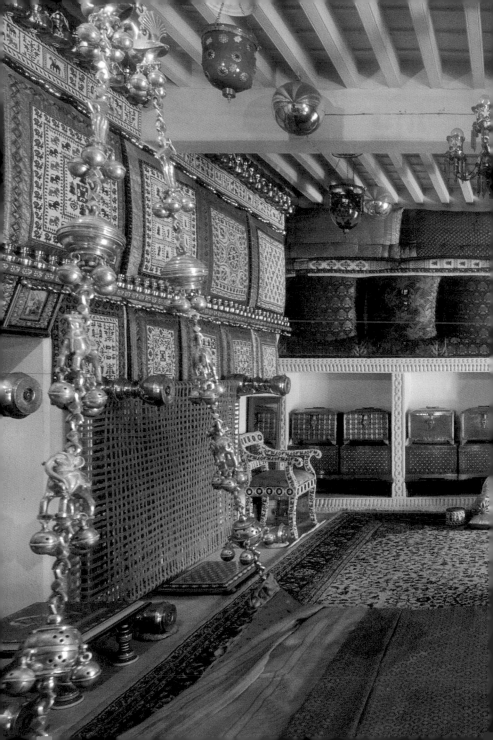

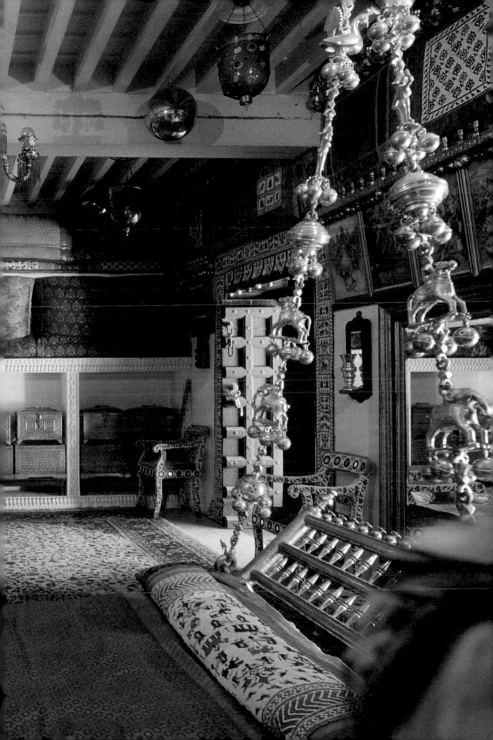

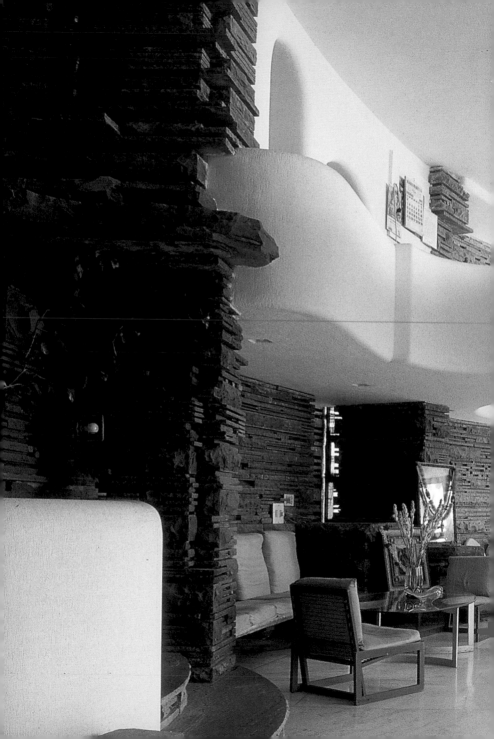

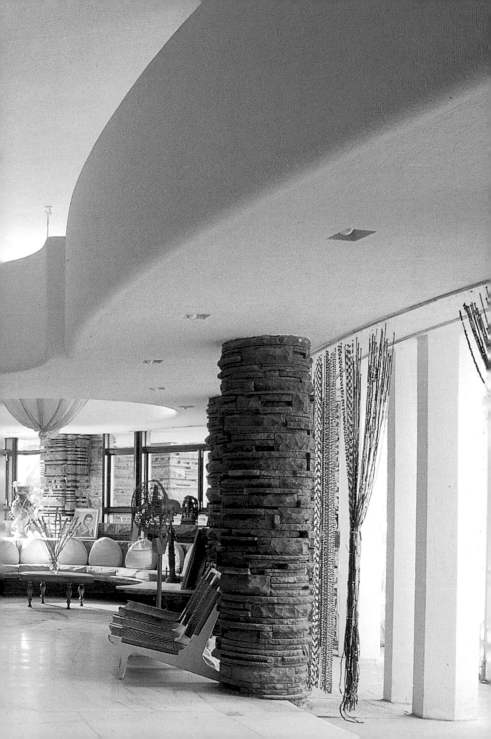

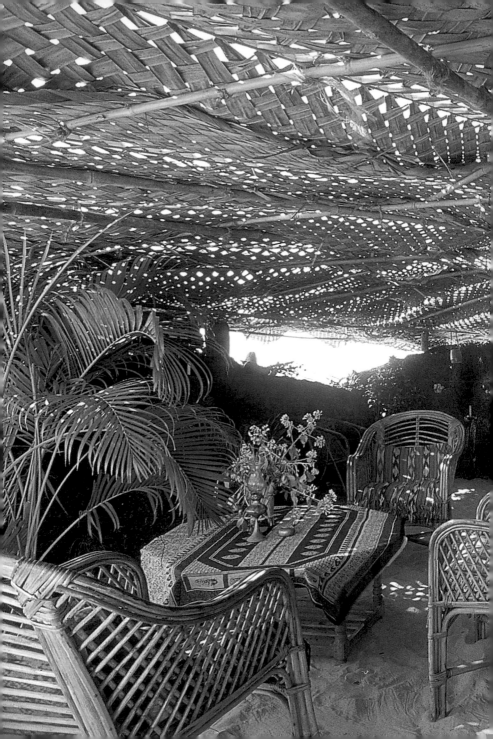

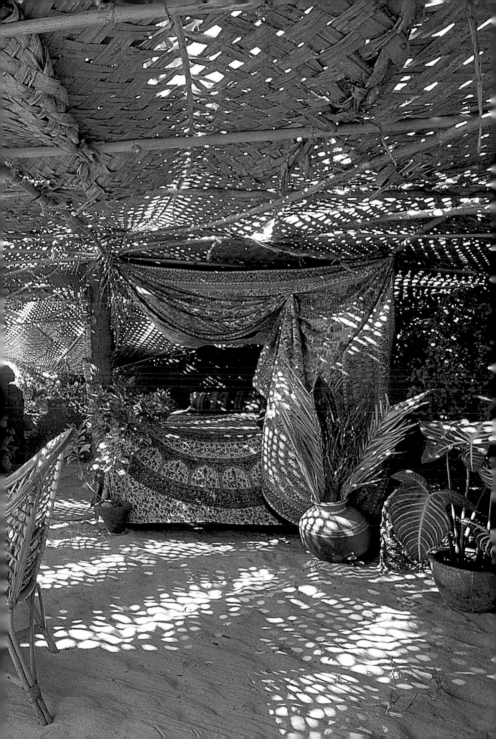

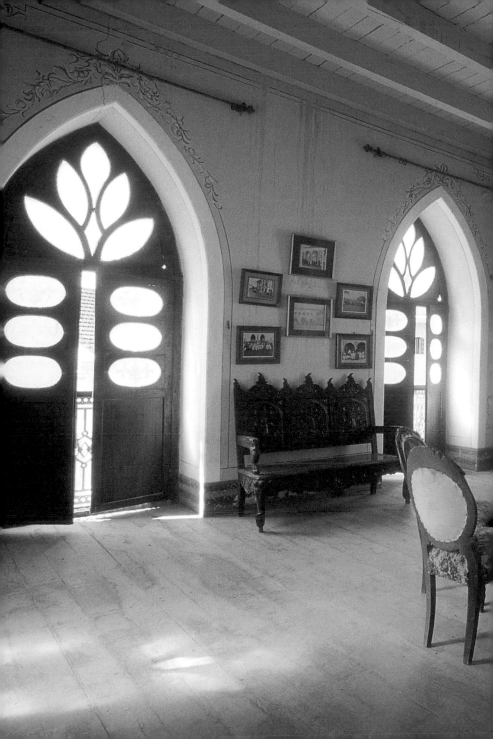

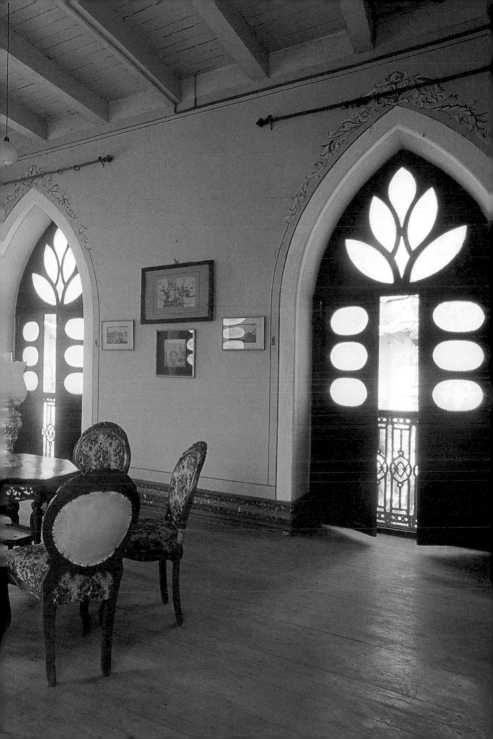

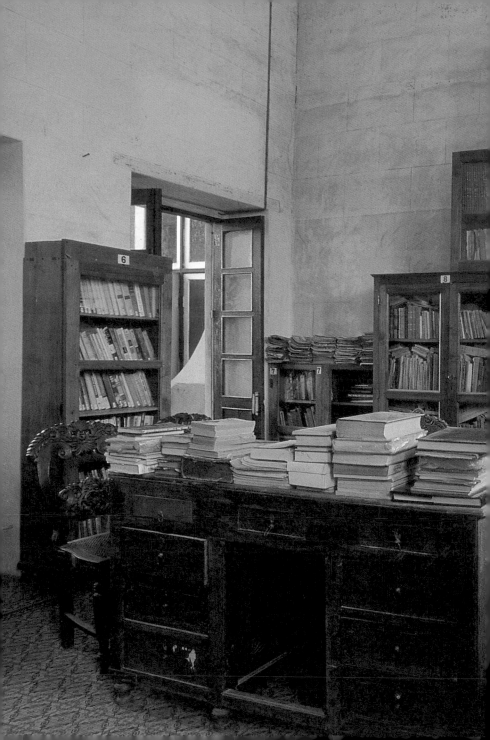

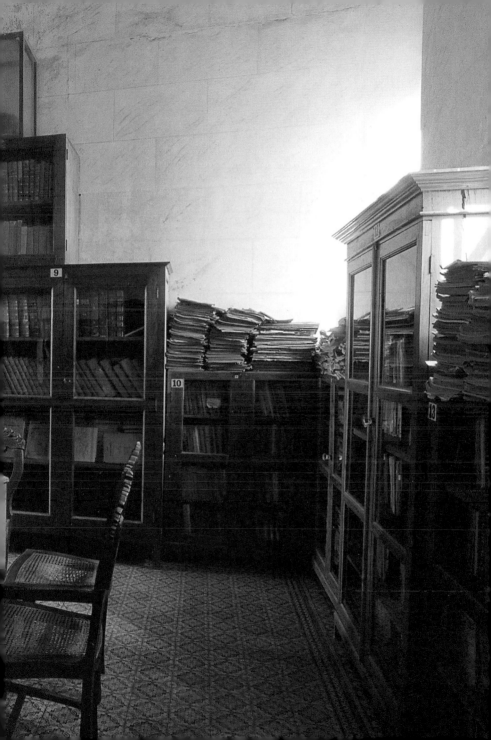

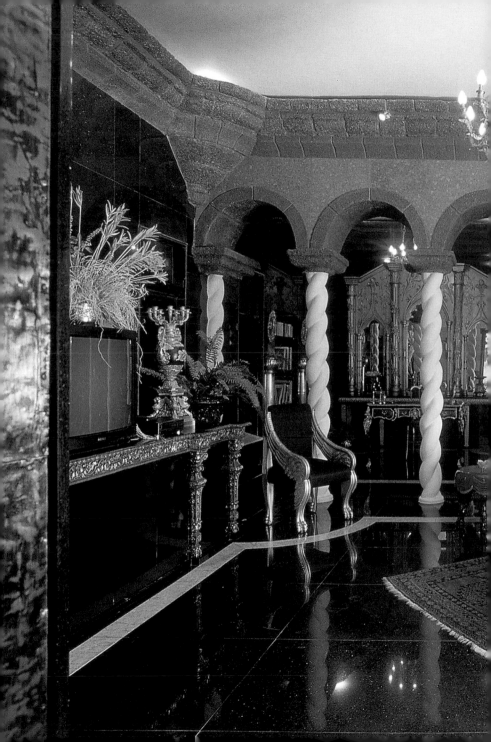

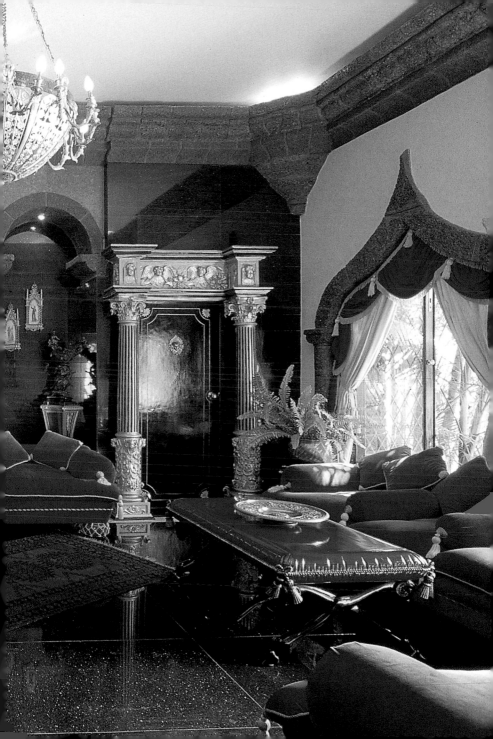

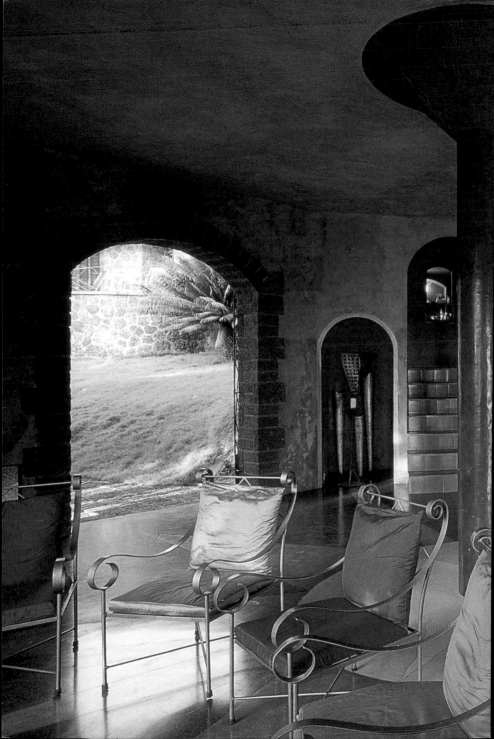

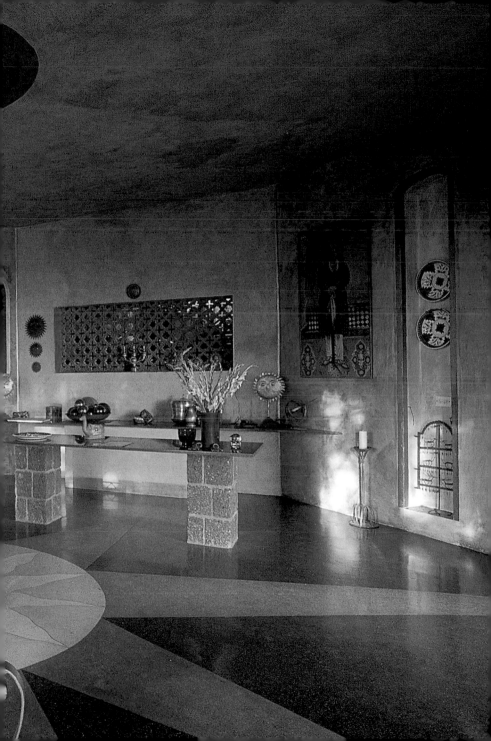

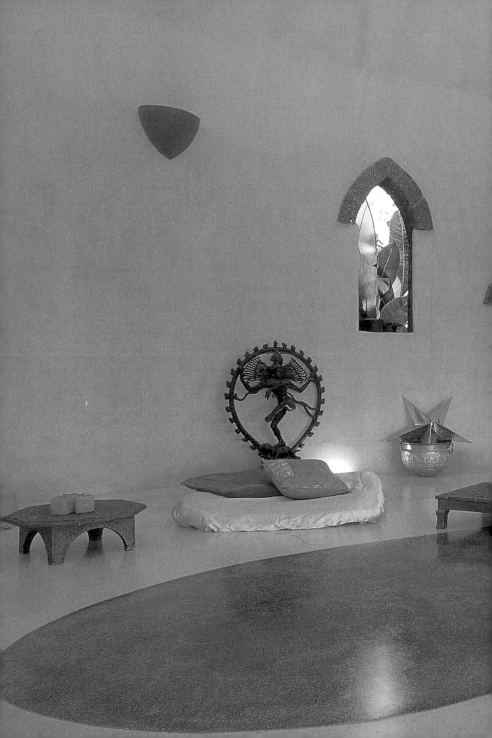

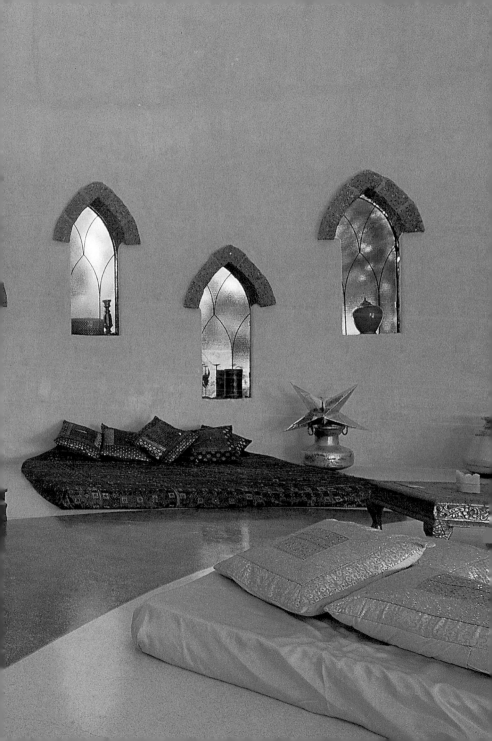

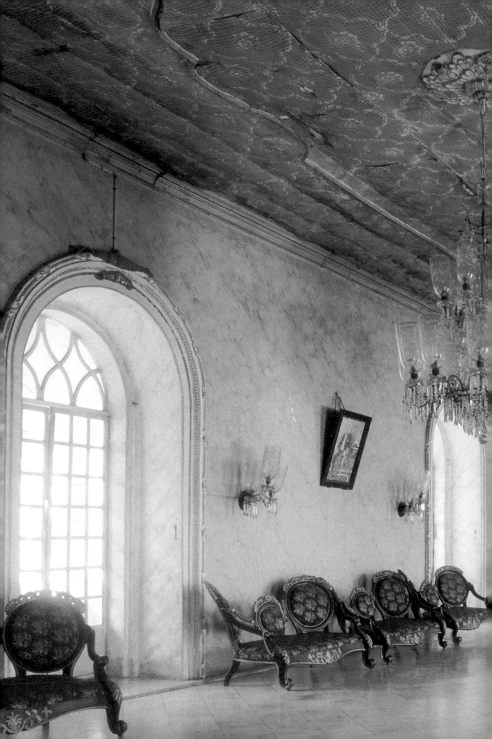

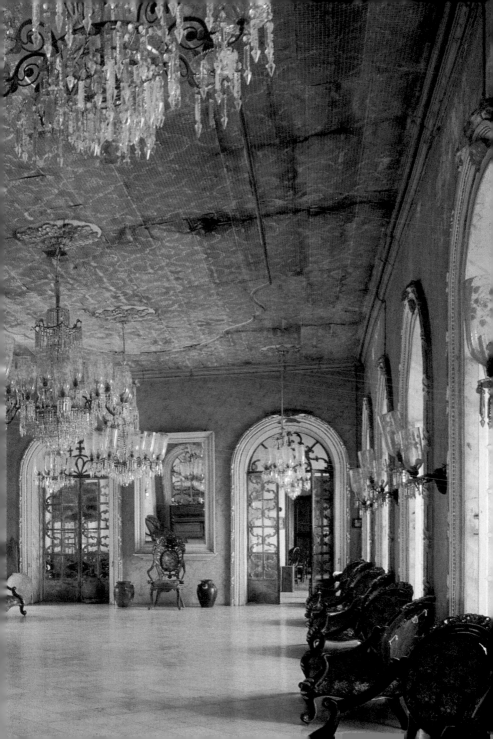

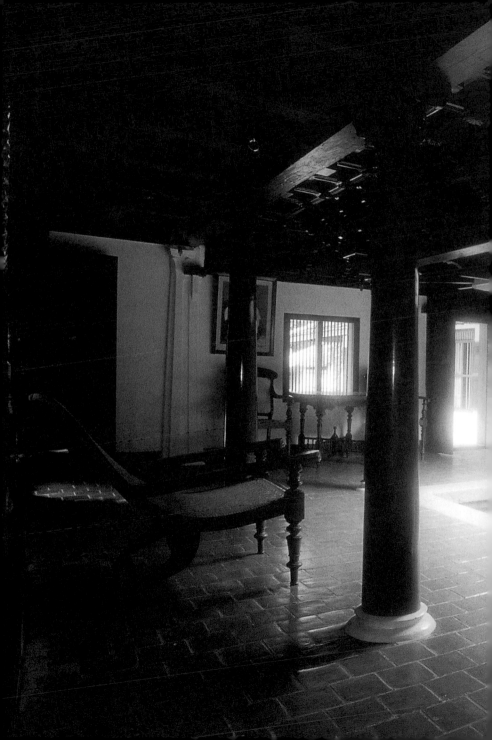

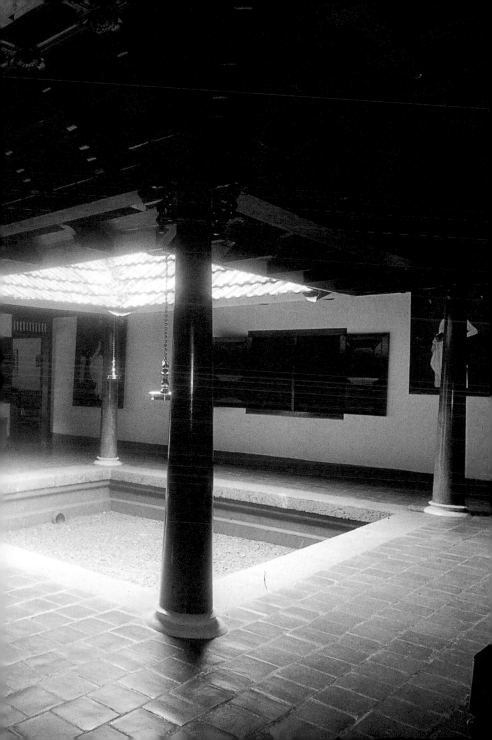

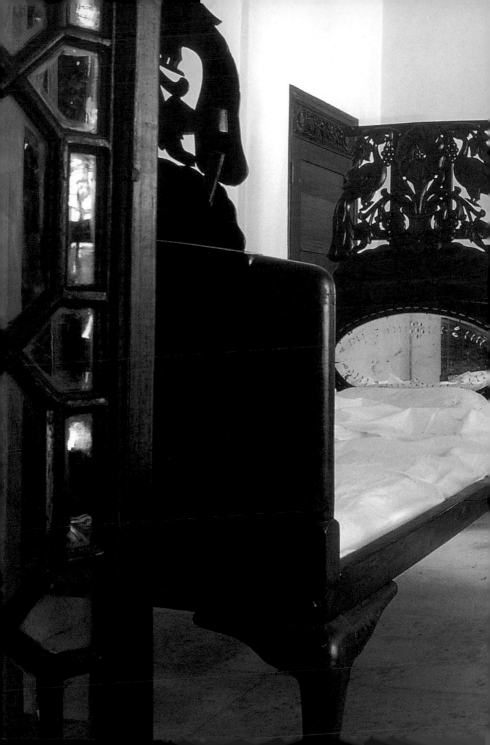

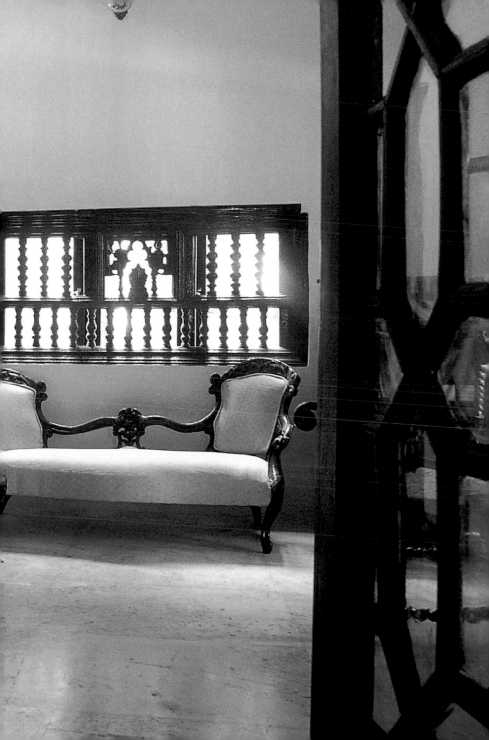

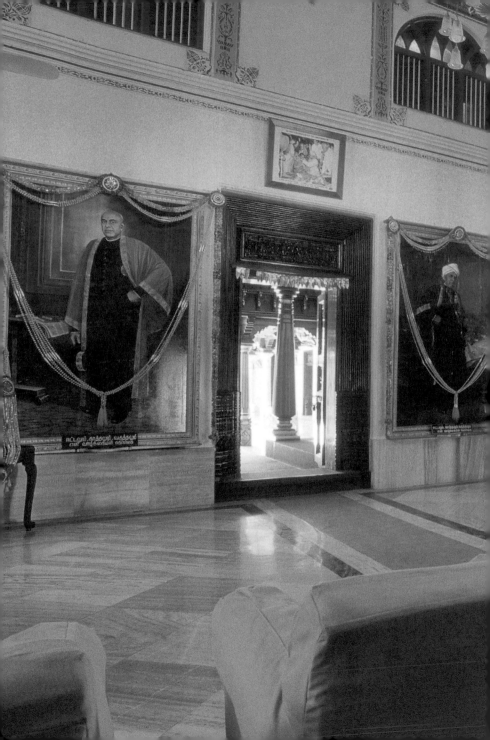

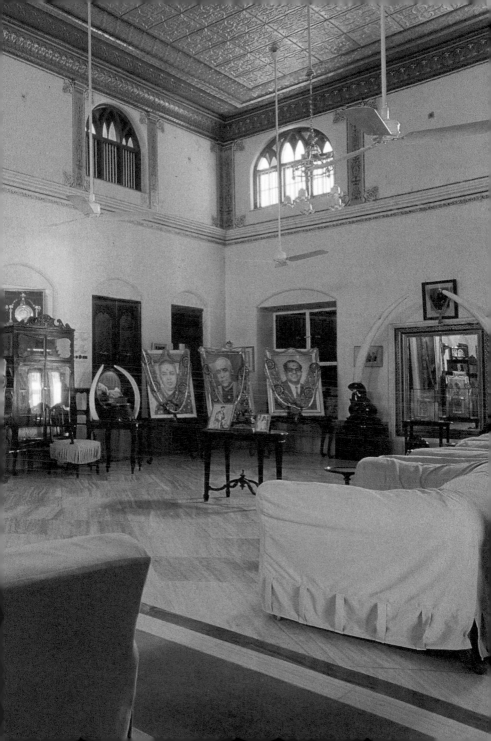

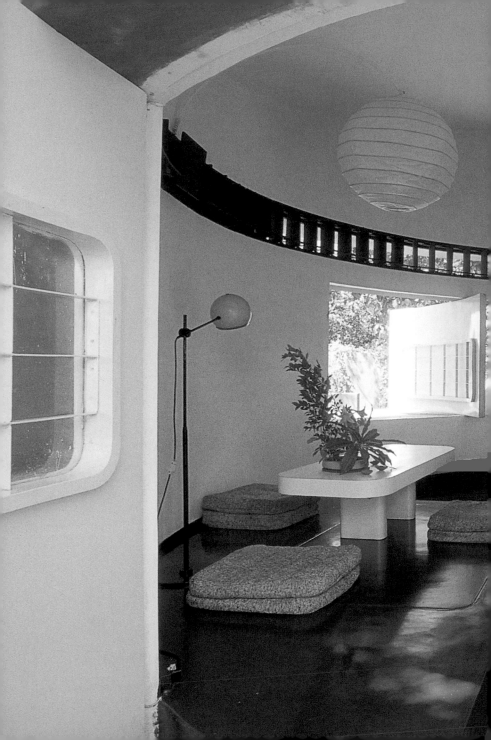

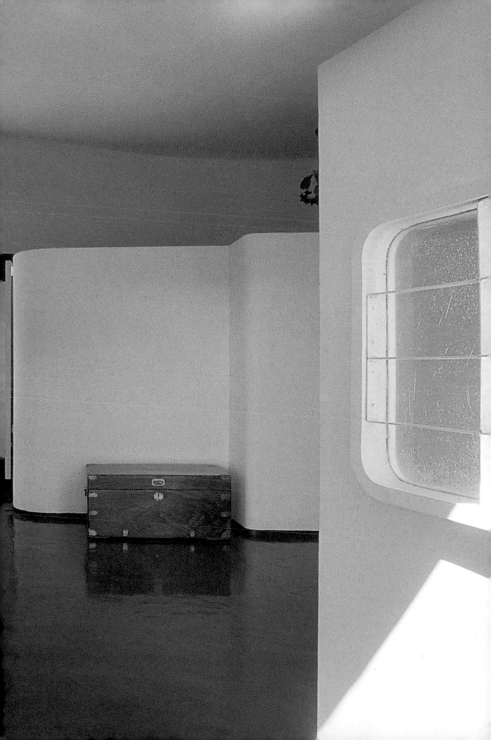

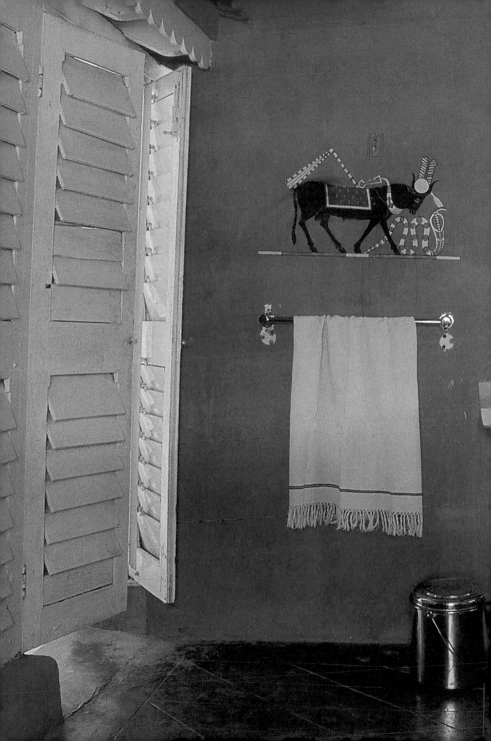

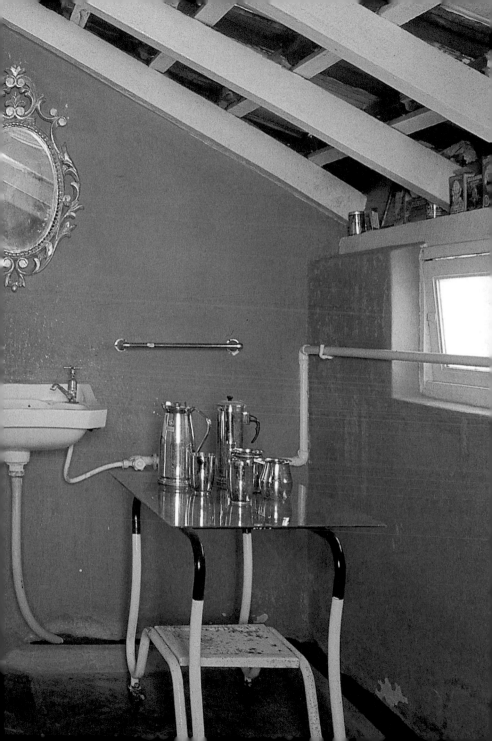

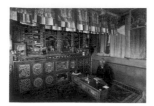

68/69 In the richly decorated private temple of a Buddhist farmer in Leh. *Dans le temple privé et richement décoré d'un agriculteur bouddhiste à Leh.* Im reich geschmückten Haustempel eines buddhistischen Bauern in Leh.

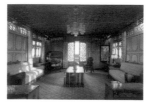

70/71 This luxury houseboat in Kashmir is fitted out with walnut furniture. *Cette luxueuse maison flottante au Cachemire est garnie de meubles en noyer.* Luxuriöses Hausboot in Kaschmir mit Möbeln aus Walnussholz.

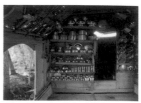

72/73 A houseboat kitchen in Kashmir with typical metall bowls and platters. *La cuisine d'une maison flottante au Cachemire avec ses plats typiques en métal.* Die Küche eines Hausboots in Kaschmir.

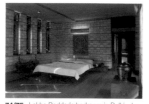

74/75 Lekha Poddar's bedroom in Delhi. *La chambre à coucher de Lekha Poddar à Delhi.* Das Schlafzimmer von Lekha Poddar in Delhi.

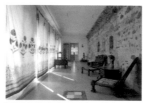

76/77 Inside the house of Aman Nath and Francis Wacziarg in Neemrana. *Dans la maison d'Aman Nath et Francis Wacziarg à Neemrana.* In dem Haus von Aman Nath und Francis Wacziarg in Neemrana.

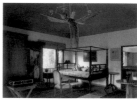

78/79 O. P. Jain's bedroom in Sanskriti Kendra, a Delhi cultural centre. *La chambre à coucher d'O. P. Jain à Sanskriti Kendra, un centre culturel de Delhi.* O. P. Jains Schlafzimmer im Sanskriti Kendra, einem Kulturzentrum in Delhi.

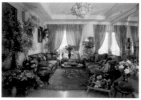

80/81 The lavish bedroom of Shahnaz Husain in Delhi. *La chambre à coucher somptueuse de Shahnaz Husain à Delhi.* Das üppige Schlafzimmer von Shahnaz Husain in Delhi.

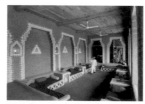

82/83 The ancient fort Castle Mandawa in Rajasthan now serves as a hotel. *L'ancien fort Castle Mandawa au Rajasthan sert aujourd'hui d'hôtel.* Das ehemalige Fort Castle Mandawa in Rajasthan ist heute ein Hotel.

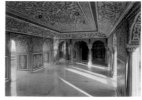

84/85 The Chhavi Niwas, or Hall of Images, in the maharaja's palace of Jaipur. *Le Chhavi Niwas, ou Salon des images, au palais du maharaja de Jaipur.* Das Chhavi Niwas, die Halle der Bilder, im Maharaja-Palast von Jaipur.

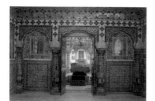

86/87 The Shobha Niwas, or Hall of Beauty, in the maharaja's palace of Jaipur. *Le Shobha Niwas, ou Salon de la beauté, au palais du maharaja de Jaipur.* Shobha Niwas, die Halle der Schönheit, im Maharaja-Palast von Jaipur.

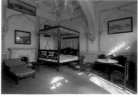

88/89 A bedroom of the villa Narain Niwas, built in the 20s at Jaipur. *Une chambre de la villa Narain Niwas, érigée dans les années 20 à Jaipur.* Ein Schlafzimmer der Villa Narain Niwas aus den 20er Jahren in Jaipur.

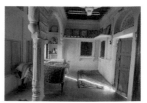

90/91 In a goldsmith's "haveli", or traditional mansion, in Jodhpur. *Dans le «haveli», ou demeure traditionnelle, d'un orfèvre à Jodhpur.* In dem »haveli«, einem traditionellen Wohnhaus, eines Goldschmieds in Jodhpur.

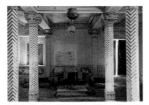

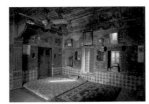

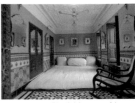

92/93 The beautifully painted Throne Room in the Old Palace of Dungarpur. *La Salle du trône avec ses magnifiques peintures au Vieux palais de Dungarpur.* Der wunderschön bemalte Thronsaal im Alten Palast von Dungarpur.

94/95 The main reception room of the Kothari Haveli in Churu, Rajasthan. *Le grand salon de réception traditionnel du Kothari Haveli de Churu au Rajasthan.* Der Hauptempfangssalon im Kothari Haveli in Churu in Rajasthan.

96/97 In the traditional sitting room of the Kothari Haveli in Bikaner, Rajasthan. *Le salon traditionnel du Kothari Haveli de Bikaner au Rajasthan.* Im traditionellen Wohnraum des Kothari Haveli in Bikaner in Rajasthan.

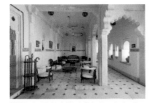

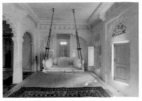

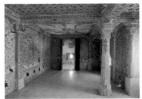

98/99 Inside Narlai Fort, Rajasthan, today the home of Raghavendra Rathore. *Au fort de Narlai au Rajasthan, aujourd'hui habité par Raghavendra Rathore.* In Narlai Fort in Rajasthan, Wohnsitz von Raghavendra Rathore.

100/101 White dominates the living room of the Amet Haveli in Udaipur. *Le blanc règne dans le séjour du Amet Haveli à Udaipur.* Die Farbe Weiß beherrscht das Wohnzimmer des Amet Haveli in Udaipur.

102/103 The magnificent private apartment of the Dungarpur rulers. *Le magnifique appartement privé des souverains de Dungarpur.* Die herrlichen Privatgemächer der Herrscher von Dungarpur.

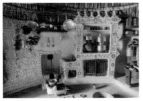

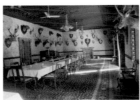

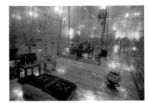

104/105 Kitchen corner in a traditional Rabari hut in the Rann of Kutch. *Le coin cuisine d'une hutte Raban traditionnelle dans le Rann de Kutch.* Kochecke in einer traditionellen Rabari-Hütte in der Rann von Kutch.

106/107 The dining room at Udai Bilas Palace in Dungarpur. *La salle à manger du Udai Bilas Palace à Dungarpur.* Das Esszimmer im Udai Bilas Palace in Dungarpur.

108/109 The shimmering Glass Chamber of the palace of Wankaner, Gujarat. *La Chambre de verre du palais de Wankaner dans le Gujerat.* Das schimmernde Glasgemach im Palast von Wankaner in Gujarat.

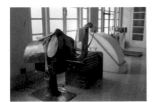

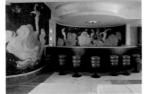

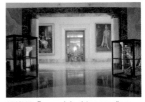

110/111 The private gym of Princess Uma in the Morvi Palace, Gujarat. *Le gymnase de la princesse Uma au Morvi Palace dans le Gujerat.* Der Fitnessraum der Prinzessin Uma im Morvi Palace in Gujarat.

112/113 Polish artist Stefan Norblin decorated the bar in the Morvi Palace. *L'artiste polonais Stefan Norblin a décoré le bar du Morvi Palace.* Der polnische Künstler Stefan Norblin dekorierte die Bar des Morvi Palace.

114/115 Foyer and view into a marvellous dining room of the Morvi Palace. *Le foyer du Morvi Palace s'ouvre sur une superbe salle à manger.* Foyer und Blick in ein prachtvolles Esszimmer im Morvi Palace.

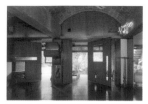

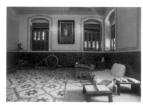

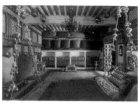

116/117 Inside Manorama Sarabhai's villa in Ahmedabad, designed by Le Corbusier. *Dans la villa Manorama Sarabhai à Ahmedabad, conçue par Le Corbusier.* In der Manorama-Sarabhai-Villa von Le Corbusier in Ahmedabad.

118/119 In the plain ashram of Mahatma Gandhi in Bombay. *Dans le sobre ashram de Mahatma Gandhi à Bombay.* Im schlichten Ashram von Mahatma Gandhi in Bombay

120/121 A drawing room in the ladies' wing of the palace at Jasdan, Gujarat. *Un salon dans l'aile des femmes du palais de Jasdan dans le Gujarat.* Ein Salon im Frauenflügel des Palastes von Jasdan in Gujarat.

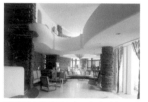

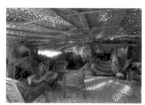

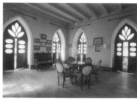

122/123 In the home of movie star Asha Parekh on Juhu beach near Bombay. *Dans la maison de l'actrice Asha Parekh sur la plage de Juhu près de Bombay.* Im Haus von Film-star Asha Parekh am Juhu-Strand bei Bombay.

124/125 This Goa beach hut is built of bamboo and palm-leaves. *Cette cabane de plage de Goa est en bambou et en feuilles de palmier.* Diese Strandhütte in Goa besteht aus Bambus und Palmblättern.

126/127 Doors with ogive arches decorate this room of the Palacio de Pernem, Goa. *Des portes en ogive ornent cette salle du Palacio de Pernem à Goa.* Spitzbogentürcn zieren dieses Zimmer im Palacio von Pernem in Goa.

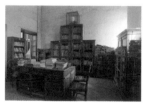

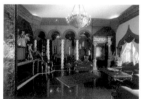

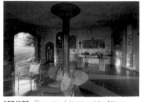

128/129 Inside the library of the Palacio de Pernem. *Dans la bibliothèque du Palacio de Pernem.* In der Bibliothek des Palacio de Pernem.

130/131 Interior view of the exuberant villa of Jimmy Gazdar in Goa. *Vue intérieure de la villa exubérante de Jimmy Gazdar à Goa.* Innenansicht der fantastischen Villa von Jimmy Gazdar in Goa.

132/133 The colourful lobby of the Nilaya Hermitage, Goa. *La réception aux couleurs vives de Nilaya Hermitage à Goa.* Das farbenfrohe Foyer des Nilaya Hermitage in Goa.

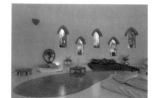

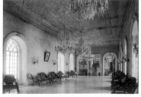

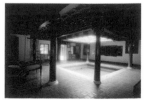

134/135 The saffron-coloured music room of the Nilaya Hermitage. *La salle de musique couleur safran de Nilaya Hermitage.* Das safranfarbene Musikzimmer des Nilaya Hermitage.

136/137 The grand ballroom of the Casa de Braganza in Chandor, Goa. *La grande salle de bal de la Casa de Braganza à Chandor, Goa.* Der großartige Ballsaal der Casa de Braganza in Chandor in Goa.

138/139 A courtyard in M. J. Kuruvinakunnel's house near Cochin. *Une cour intérieure de la maison de M. J. Kuruvinakunnel près de Cochin.* Ein Innenhof im Haus von M. J. Kuruvinakunnel bei Cochin.

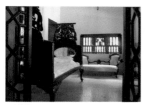 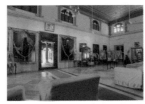 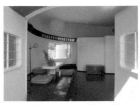

140/141 Mathew Lawrence's guest room in Cochin, Kerala. *La chambre d'amis de Mathew Lawrence à Cochin au Kerala.* Das Gästezimmer von Mathew Lawrence in Cochin in Kerala.

142/143 Ancestral portraits dominate this hall in Chettinad Palace, Tamil Nadu. *Des portraits d'ancêtres dominent cette salle du Chettinad Palace, Tamil Nadu.* Ahnenporträts in einer 8 Halle im Chettinad Palace, Tamil Nadu.

144/145 The sitting room of Christine Devin at Auroville has curved walls. *Le séjour de Christine Devin à Auroville a des parois incurvées* Das Wohnzimmer von Christine Devin in Auroville verfügt über geschwungene Wände.

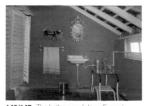

146/147 The bathroom of Jean-François Lesage and Patrick Savouret in Madras. *La salle de bains de Jean-François Lesage et Patrick Savouret à Madras.* Das Badezimmer von Jean-François Lesage und Patrick Savouret in Madras.

148/149 Rice paste patterns decorate the hut of a rice grower in Orissa. *Des motifs en pâte de riz ornent la cabane d'un riziculteur de l'Orissa.* Muster aus Reispaste zieren die Hütte eines Reisbauern in Orissa.

"Pink is the Navy Blue of India."
Diana Vreeland, fashion editor

«Le rose est le bleu roi de l'Inde.»
Diana Vreeland, fashion editor

«Pink ist das Königsblau Indiens.»
Diana Vreeland, fashion editor

DETAILS

Détails Details

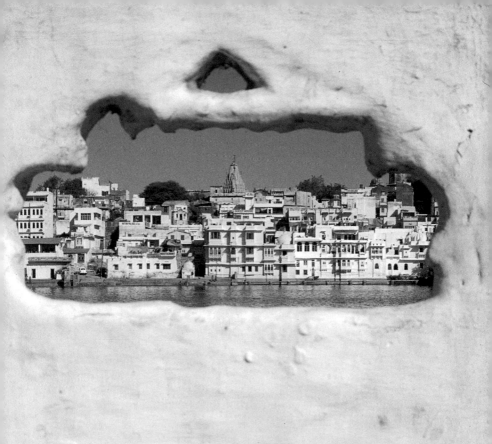

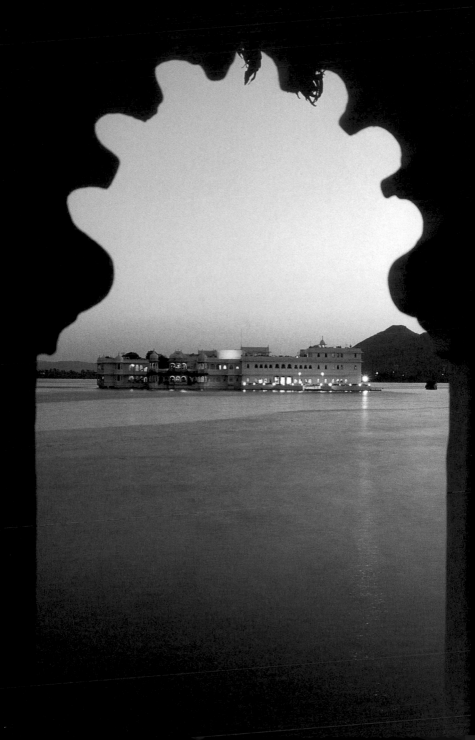

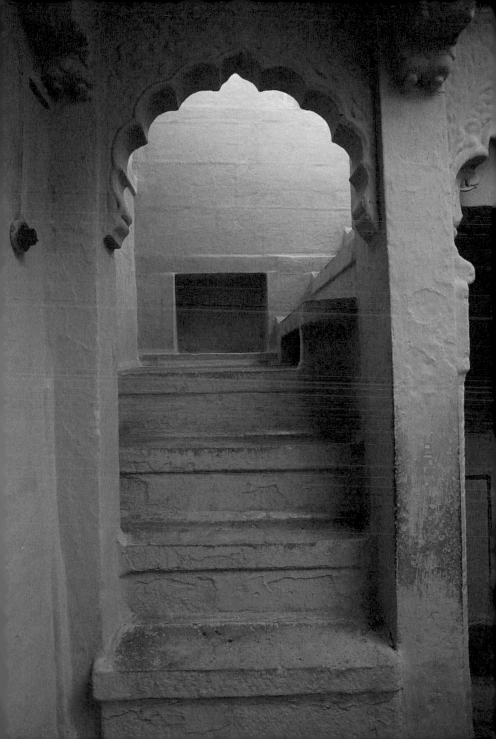

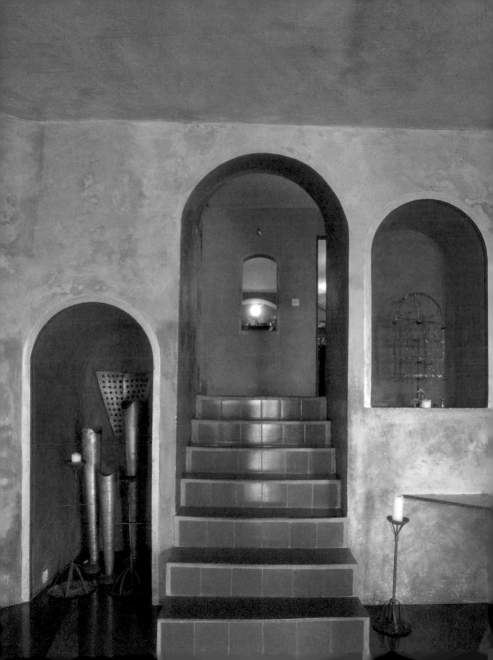

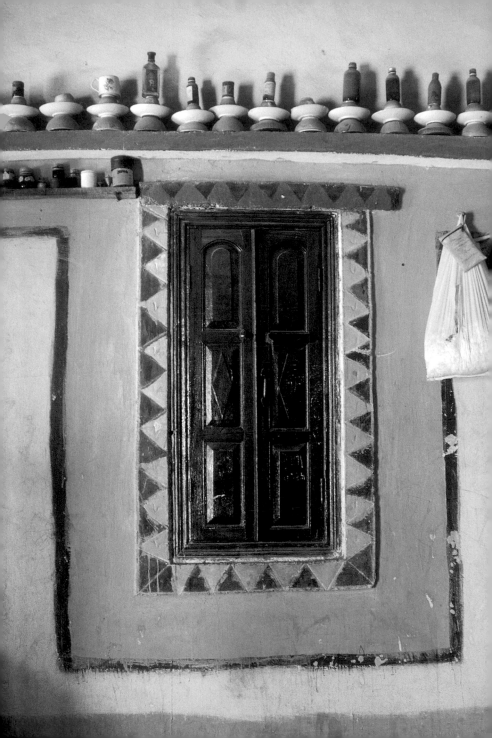

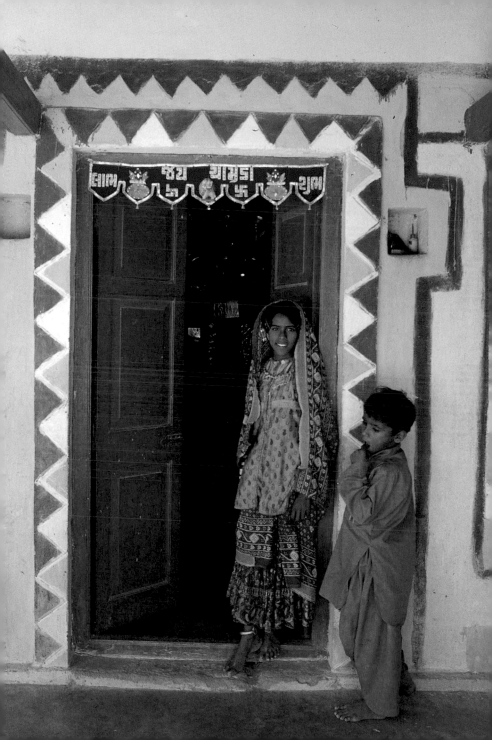

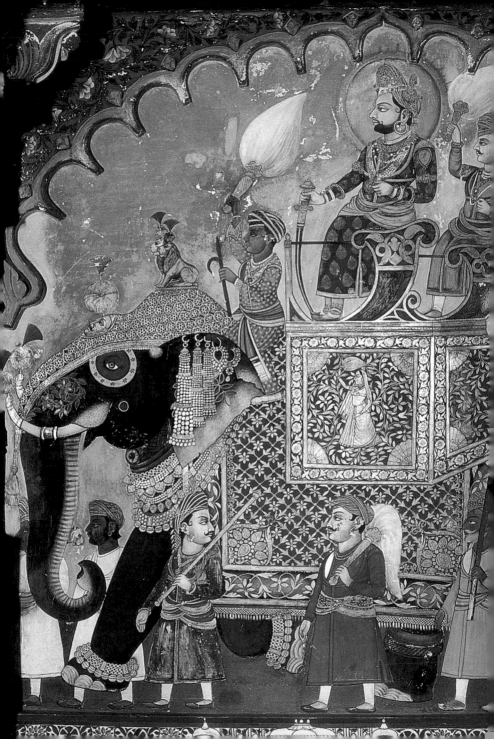

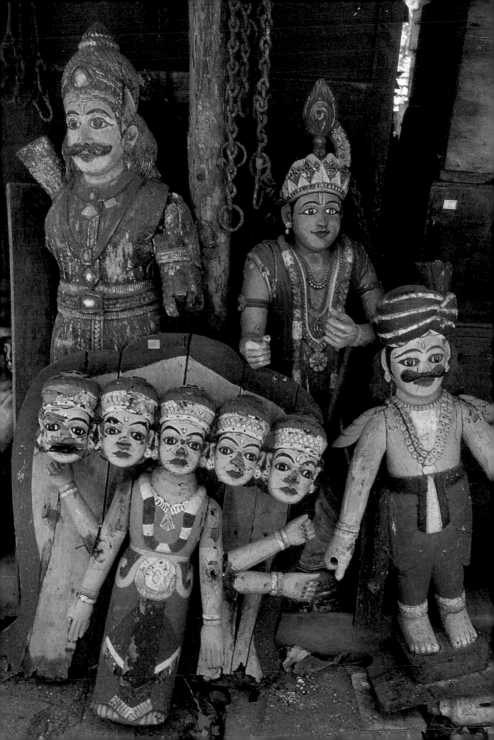

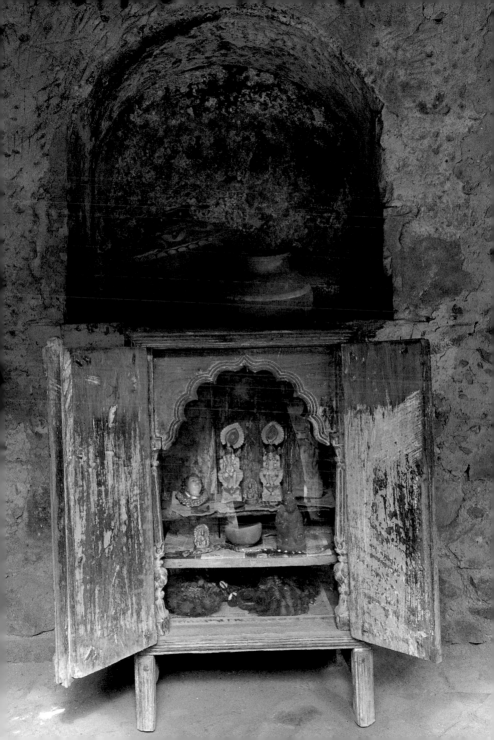

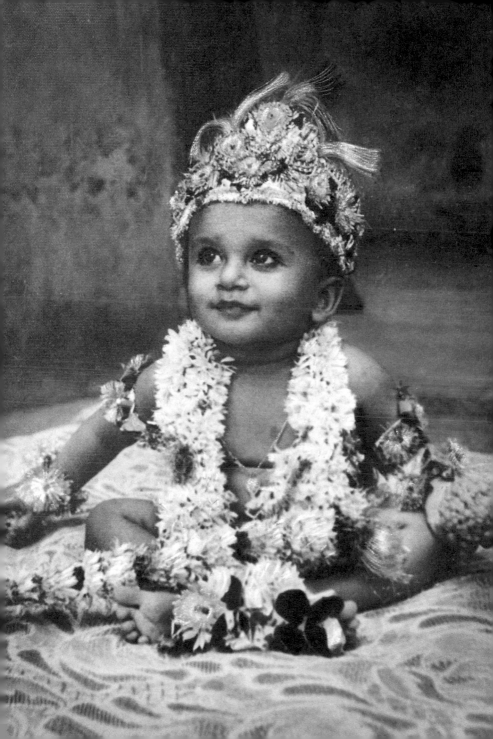

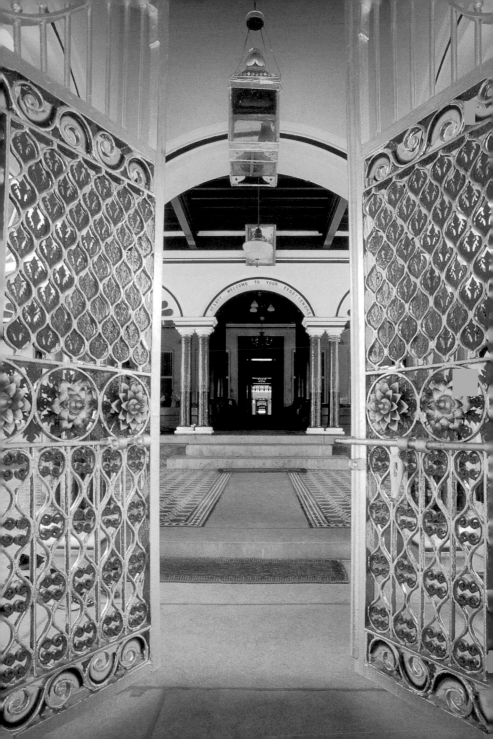

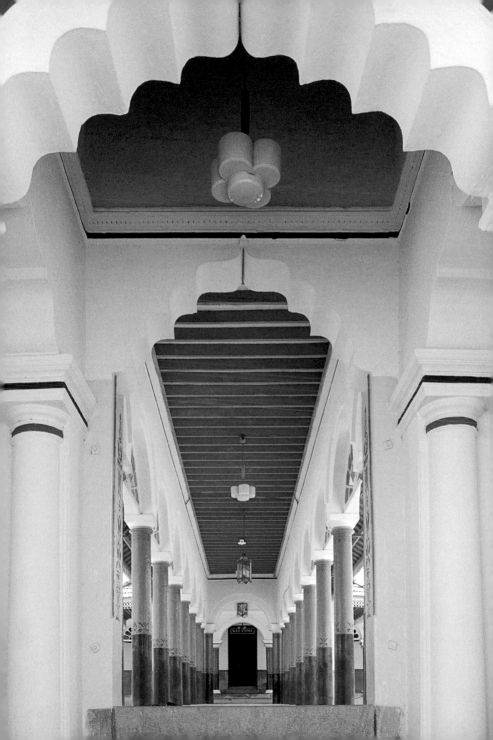

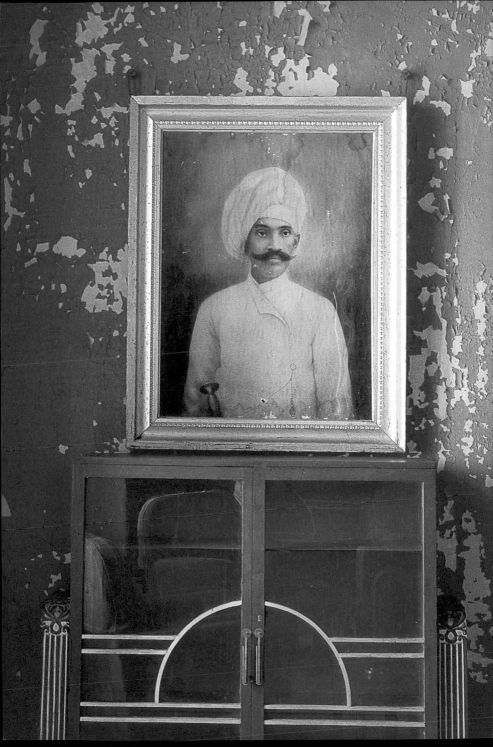

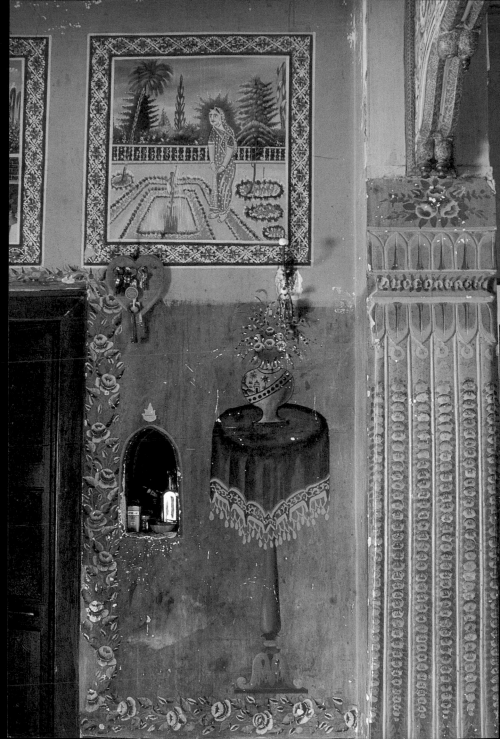

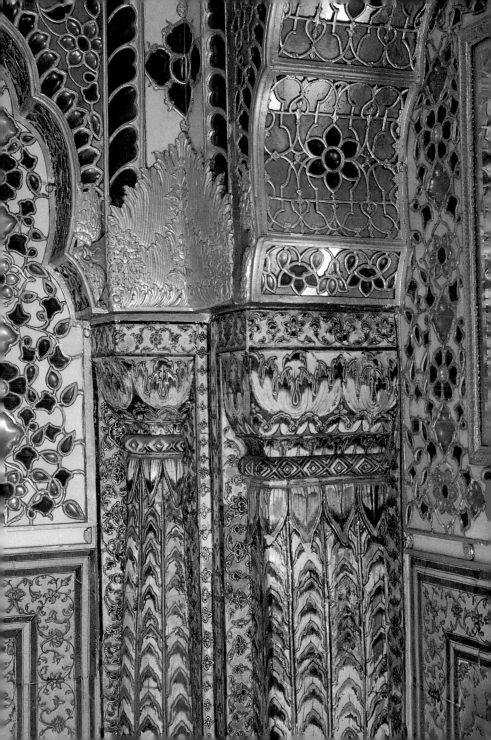

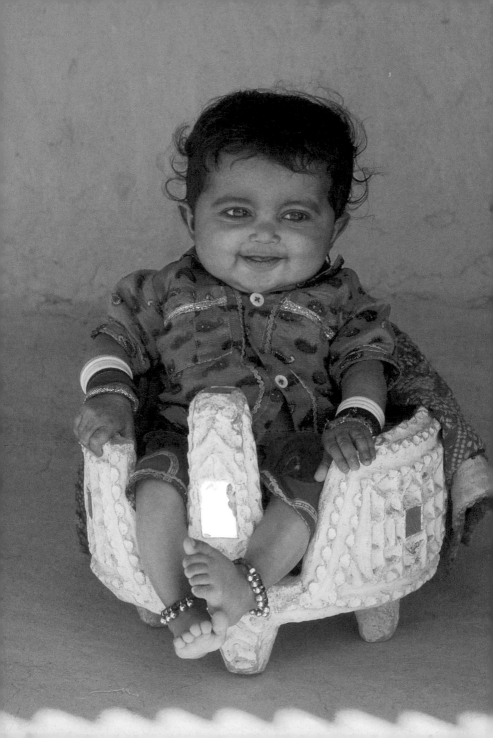

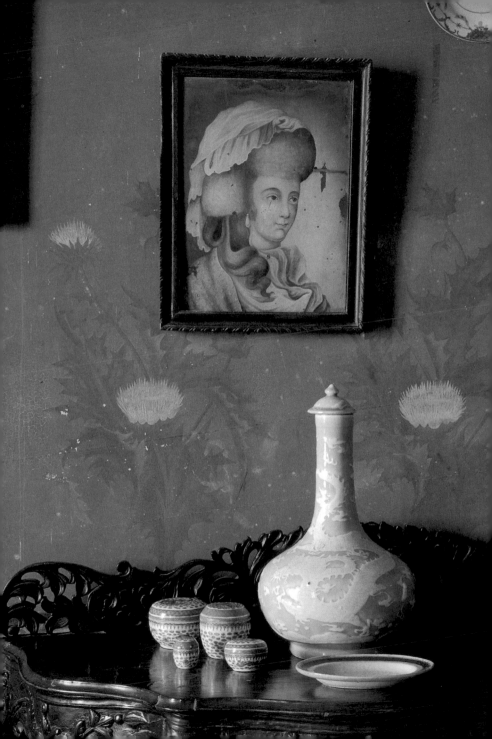

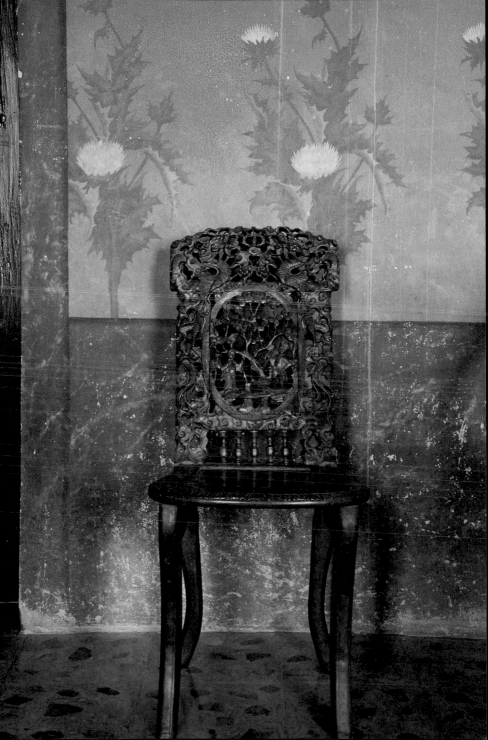

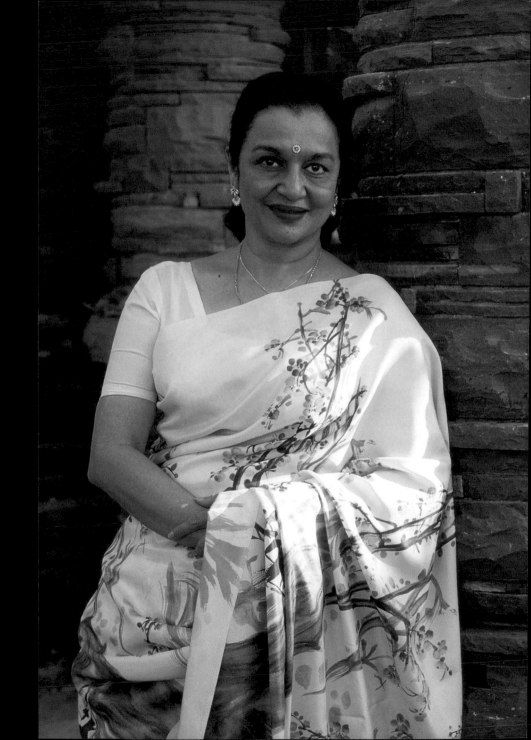

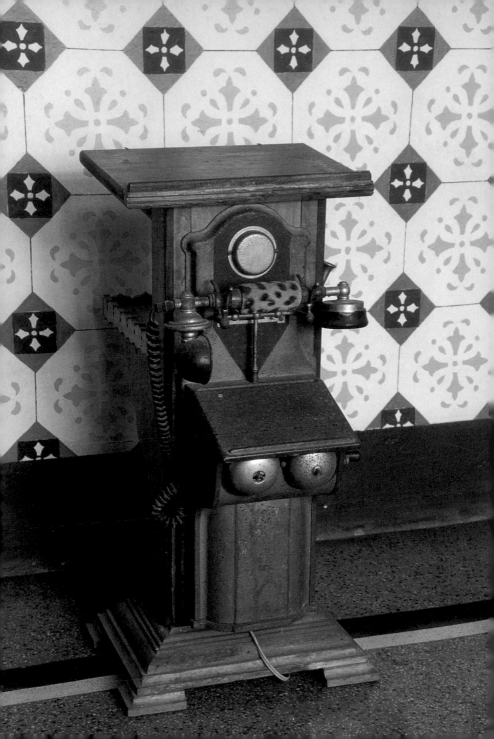

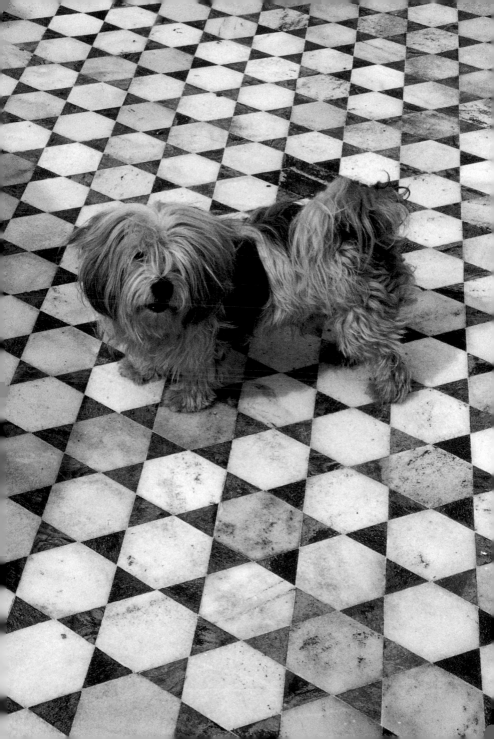

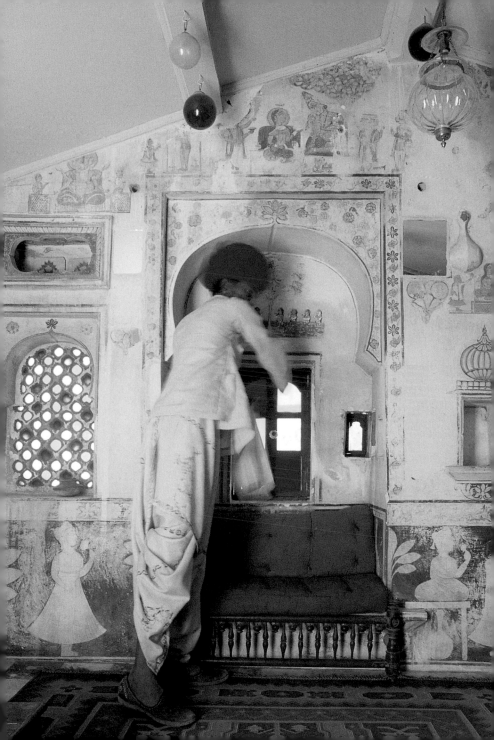

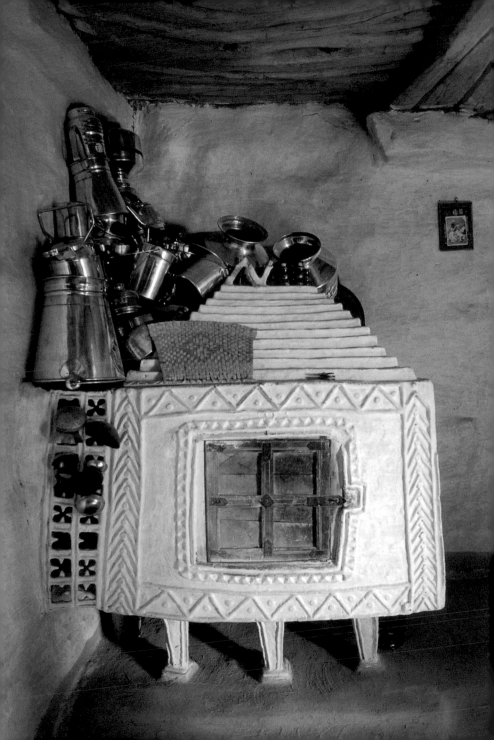

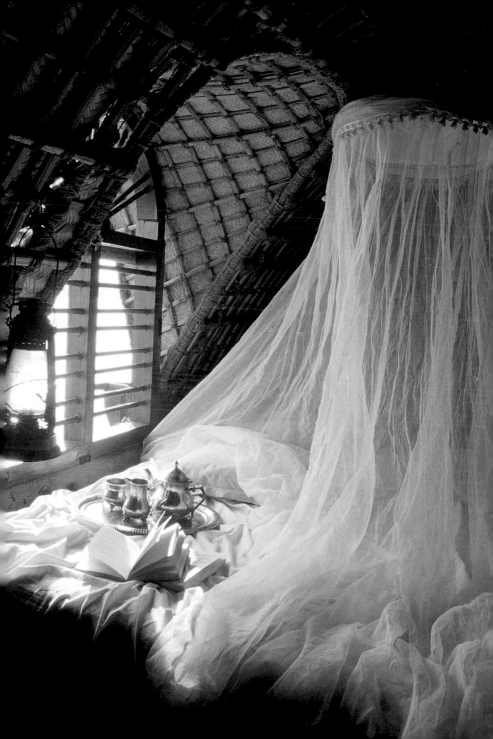

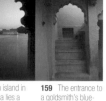

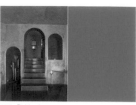

157 View from the pierced wall of the pavilion of Amet Haveli on Udaipur. *Udaipur vu à travers le mur ajouré du pavillon d'Amet Haveli.* Blick durch ein Mauerornament von Amet Havelis Pavillon auf Udaipur.

158 On an island in Lake Pichola lies a palace from the 17th century. *Sur une île du lac Pichola se trouve un palais du 17ᵉ siècle.* Auf einer Insel im Pichola-See liegt ein Palast aus dem 17. Jahrhundert.

159 The entrance to a goldsmith's blue-washed "haveli" in Jodhpur. *L'entrée du «haveli» badigeonné en bleu d'un orfèvre à Jodhpur.* Der Eingang zu dem blaugetünchten »haveli« eines Goldschmieds in Jodhpur.

160 Bold colours dominate the interiors of Nilaya Hermitage, Goa. *Des couleurs vives dominent les intérieurs de Nilaya Hermitage à Goa.* Kräftige Farben beherrschen die Räume des Nilaya Hermitage in Goa.

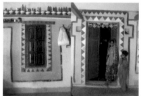

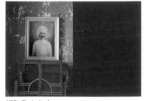

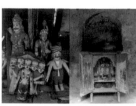

162 The painted window of a Meghwal house in the Rann of Kutch. *La fenêtre peinte d'une maison Meghwal dans le Rann de Kutch.* Das bemalte Fenster eines Meghwal-Hauses in der Rann von Kutch.

163 In front of a Meghwal house. The Meghwals are a caste of leather workers. *Devant une maison Meghwal. Les Meghwal sont une caste de tanneurs.* Vor einem Meghwal-Haus. Die Meghwals stellen Lederwaren her.

164 A 19th-century fresco showing Udai Singh II, Maharaja of Dungarpur. *Cette fresque du 19ᵉ siècle montre Udai Singh II, le maharaja de Dungarpur.* Fresko aus dem 19. Jh. mit Udai Singh II., Maharaja von Dungarpur.

166 These images of Indian deities were used in religious processions. *Ces statuettes de divinités indiennes étaient exposées dans des processions.* Diese indischen Götterfiguren wurden bei Prozessionen benutzt.

167 A painted cupboard in the house of Aman Nath and Francis Wacziarg. *Un bahut peint dans la maison d'Aman Nath et Francis Wacziarg.* Ein bemalter Schrank im Haus von Aman Nath und Francis Wacziarg.

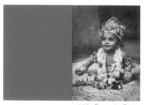

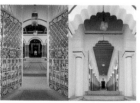

169 Devendra Deshprabhu as a child. He now resides in the Palacio de Pernem, Goa. *Devendra Deshprabhu enfant. Il habite aujourd'hui le Palacio de Pernem, Goa.* Devendra Deshprabhu als Kind. Er lebt heute im Palacio de Pernem, Goa.

170 Huge iron gates open onto the pillared entrance to Chettinad Palace, Tamil Nadu. *De vastes portails en fer s'ouvrent sur le porche à colonnes du Chettinad Palace.* Große Eisentore führen zur Säulenhalle des Chettinad Palace.

171 Painted pillars decorate this courtyard in Chettinad Palace, Tamil Nadu. *Des colonnes peintes décorent cette galerie du Chettinad Palace au Tamil Nadu.* Bemalte Säulen im Chettinad Palace in Tamil Nadu.

172 Portrait of Alakhachar II in a room of the Jasdan Palace, Gujarat. *Portrait d'Alakhachar II dans une pièce du palais de Jasdan, Gujerat.* Porträt von Alakhachar II. im Jasdan Palace in Gujarat.

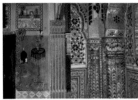
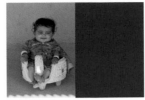
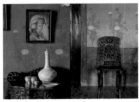

174 Detail of a painted wall of the Kothari Haveli in Churu, Rajasthan. *Détail d'un mur peint du Kothari Haveli de Churu au Rajasthan.* Detail einer bemalten Wand im Kothari Haveli in Churu in Rajasthan.

175 Gold-leaf and mica decoration in the palace of the Maharaja of Jaipur. *Ornements en mica et à la feuille d'or au palais du maharaja de Jaipur.* Muskovit und Blattgold im Palast des Maharaja von Jaipur

176 A Rabari Child on a decorated clay seat. *Un enfant Rabari sur un siège en argile décoré.* Ein Rabari-Kind auf einem verzierten Lehmstühlchen.

178 Interior detail of the Casa de Braganza in the village of Chandor, Goa. *Détail de la Casa de Braganza au village de Chandor, Goa.* Detailansicht aus der Casa de Braganza in dem Städtchen Chandor in Goa.

179 Chinese chair in a room of the Casa de Braganza. *Une chaise chinoise dans une salle de la Casa de Braganza.* Ein chinesischer Stuhl in einem Raum der Casa de Braganza.

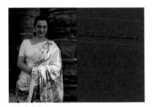
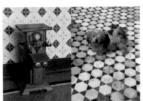

180 India's top movie star, Asha Parekh. *La grande star du cinéma indien, Asha Parekh.* Der berühmte indische Filmstar Asha Parekh.

182 The Bell & Co. telephone in the Palacio de Pernem dates from 1902. *Le téléphone de Bell & Co. au Palacio de Pernem date de 1902.* Das Telefon von Bell & Co. im Palacio de Pernem stammt von 1902.

183 The tiny apso of film star Asha Parekh. *Le petit lhassa apso de la star de cinéma Asha Parekh.* Der kleine Lhasa-Apso Hund von Filmstar Asha Parekh.

185 Narlai Fort, Rajasthan, served originally as hunting lodge. *Le fort de Narlai au Rajasthan servait autrefois de pavillon de chasse.* Das Fort von Narlai in Rajasthan diente ursprünglich als Jagdschloss.

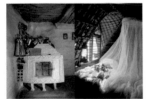
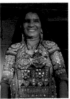

186 Storage unit in a camel-herder's mud house in Jaisalmer. *Armoire dans la maison en boue d'un chamelier à Jaisalmer.* Schränkchen in dem Lehmhaus eines Kameltreibers in Jaisalmer.

187 A romantic bedroom on a houseboat on a lagoon in Kerala. *La chambre romantique d'une maison flottante dans une lagune du Kerala.* Romantisches Schlafzimmer auf einem Hausboot in einer Lagune in Kerala.

190 Rabari women wear traditional silver jewels and embroidered blouses. *Les femmes Rabari portent des bijoux traditionnels en argent et des corsages brodés.* Rabari-Frau mit traditionellem Silberschmuck und bestickter Bluse.

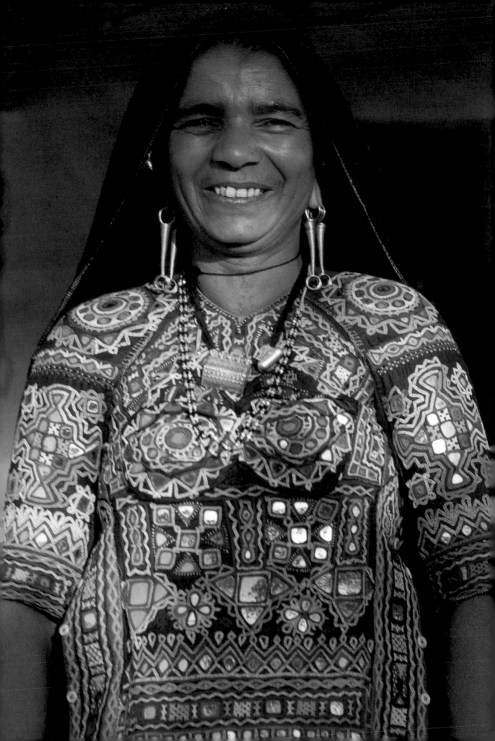

ACKNOWLEDGEMENTS / REMERCIEMENTS / DANKSAGUNG

In Delhi, special thanks to Patwant Singh, Meher Wilshaw and Rasil and Romen Basu for hosting the photographer on her numerous trips to India, and to Aman Nath and Francis Wacziarg, whose knowledge and insights were of particular value. Our thanks also to Vinu and Abbas Ali Baig, Gautam Bhatia, Rupika and Navin Chawla, Uttara Chaudhury, Niloufer Currimbhoy, Achilles and Chantal Forler, Shumila Ghose, Sagarika Ghose and Rajdeep Sardesai, Richard and Sally Holkar, David and Jenny Housego, Jyotindra and Jutta Jain, Samar Singh Jodha, Sonal Joshi, Sunita and Romesh Kohli, Prima Kurien, Momin Latif, Tim and Jan McGirk, Pradeep and Veena Mehra, Ritu and Krishna Menon, S. K. Mishra, Usha and Bhushan Mohindra, Dr Nether and Thilmann Waldraff at Max Mueller Bhawan, Amitabh Pande, Lekha Poddar, Anupam Poddar, Bina Ramani, Sabina Sehgal Saikia, Sanjeve Sethi, Brijeshwar Singh, Martand Singh, Prabeen Singh, Rena Ripjit Singh, Malvika and Tejbir Singh, Hershad Kumari Sharma and former US Ambassador to India Frank Wisner and Mrs Christine Wisner. In Kashmir and Ladakh, we are grateful to Afzal Abdulla, Jagdish Mehta, Pinto and Tsering Narboo, Feroz Khan and A. Rauf, Dolma Shri Sichoi and Gijamat Wangchuk.

In Rajasthan, particular thanks go to Randhir Vikram Singh and the Heritage Hotel Association for their kind hospitality to the photographer; also thanks to Subhash Chaturvedi, A. V. Joseph, Dr Yaduendra Sahai and K. K. Sharma. In Jodhpur, we are especially grateful to Gaj Singh II, the Maharaja of Jodhpur, Rao Raja Mahendra Singh, Dhananjaya Singh and Mahendra Singh Nagar for solving an intransigent situation with dexterity and tact; our thanks also to Thakur Sunder Singh, Prof. Karan Singh, Maharaja Swaroop Singh and Raghavendra Rathore. In Bikaner, many thanks to U. C. Kochhar, Arvind and Sushila Ojha and Siddharth Pareek, and in Udaipur to Arjun Singh and Sanjay Vyas.

In Gujarat, we benefited from the advice and assistance of Balkrishna V. Doshi and Kulbhushan Jain in Ahmedabad, Jyoti Bhatt in Baroda, Kumid Kumari in Gondal, Samita Devi in Bhavnagar and Vanka Kana Rabari in Bhuj.

In Bombay our special thanks go to Abu Jani and Sandeep Khosla: also to Shyam and Nira Benegal, Dimple Kapadia, Silvia Khan, Neeru Nanda, Sunita Pitamber, Nirja Shah, Sheila Shahani and Dr Winterberger. In Goa, we are especially obliged to Jimmy Gazdar, and to Steven Jenkins, Lidia and Alirio Lobo, Habiba and Mario Miranda, Joaquim Monteiro, Bal Mundkur, O. Thomas, Norbert Sequeiro and Babu Varghese. In Kerala, we thank Ashok Adiceam, Radar Devi, Colonel Jacobs, K. V. P. Panicker, Babu Paul and Prameswaran Nair. In Bangalore we are grateful to Mrs Fordyce, Ramu and Roshin Katakam, the late Naomi Meadows and the staff of Nrityagram.

In Madras, Michael and Anjana Hasper, Deborah Thiagarajan and Prema Srinivasan were of special help. In Pondicherry and Auroville we are indebted to Françoise L'Hernault, Veena Lemaire, Françoise Gerin, Ratna and Ajit Kujalgi. In Calcutta our special thanks to Tilottama Das, Sailendra Nath Mullick and Rakhi and Pratiti Sarkar.

**Graphic Design for the
21st Century**
Charlotte & Peter Fiell /
Flexi-cover, 640 pp. / € 29.99/
$ 39.99 / £ 19.99 / ¥ 5.900

Scandinavian Design
Charlotte & Peter Fiell /
Flexi-cover, 704 pp. / € 29.99/
$ 39.99 / £ 19.99 / ¥ 5.900

Designing the 21st Century
Ed. Charlotte & Peter Fiell /
Flexi-cover, 576 pp. / € 29.99/
$ 39.99 / £ 19.99 / ¥ 5.900

"These books are beautiful objects, well-designed and lucid." —*Le Monde*, Paris, on the ICONS series

"Buy them all and add some pleasure to your life."

African Style
Ed. Angelika Taschen

Alchemy & Mysticism
Alexander Roob

All-American Ads 40s
Ed. Jim Heimann

All-American Ads 50s
Ed. Jim Heimann

All-American Ads 60s
Ed. Jim Heimann

Angels
Gilles Néret

Architecture Now!
Ed. Philip Jodidio

Art Now
Eds. Burkhard Riemschneider,
Uta Grosenick

Atget's Paris
Ed. Hans Christian Adam

Berlin Style
Ed. Angelika Taschen

Chairs
Charlotte & Peter Fiell

Christmas
Steven Heller

Design of the 20th Century
Charlotte & Peter Fiell

Design for the 21st Century
Charlotte & Peter Fiell

Devils
Gilles Néret

Digital Beauties
Ed. Julius Wiedemann

Robert Doisneau
Ed. Jean-Claude Gautrand

East German Design
Ralf Ulrich / Photos: Ernst
Hedler

Egypt Style
Ed. Angelika Taschen

M.C. Escher

Fashion
Ed. The Kyoto Costume
Institute

HR Giger
HR Giger

Grand Tour
Harry Seidler,
Ed. Peter Gössel

Graphic Design
Ed. Charlotte & Peter Fiell

Greece Style
Ed. Angelika Taschen

Halloween Graphics
Steven Heller

Havana Style
Ed. Angelika Taschen

Homo Art
Gilles Néret

Hot Rods
Ed. Coco Shinomiya

Hula
Ed. Jim Heimann

Indian Style
Ed. Angelika Taschen

India Bazaar
Samantha Harrison,
Bari Kumar

Industrial Design
Charlotte & Peter Fiell

Japanese Beauties
Ed. Alex Gross

Krazy Kids' Food
Eds. Steve Roden,
Dan Goodsell

Las Vegas
Ed. Jim Heimann

London Style
Ed. Angelika Taschen

Mexicana
Ed. Jim Heimann

Mexico Style
Ed. Angelika Taschen

Morocco Style
Ed. Angelika Taschen

**Extra/Ordinary Objects,
Vol. I**
Ed. Colors Magazine

**Extra/Ordinary Objects,
Vol. II**
Ed. Colors Magazine

Paris Style
Ed. Angelika Taschen

Penguin
Frans Lanting

20th Century Photography
Museum Ludwig Cologne

Pin-Ups
Ed. Burkhard Riemschneider

Photo Icons I
Hans-Michael Koetzle

Photo Icons II
Hans-Michael Koetzle

Pierre et Gilles
Eric Troncy

Provence Style
Ed. Angelika Taschen

Pussycats
Gilles Néret

Safari Style
Ed. Angelika Taschen

Seaside Style
Ed. Angelika Taschen

Albertus Seba. Butterflies
Irmgard Müsch

**Albertus Seba. Shells &
Corals**
Irmgard Müsch

South African Style
Ed. Angelika Taschen

Starck
Ed Mae Cooper, Pierre Doze,
Elisabeth Laville

Surfing
Ed. Jim Heimann

Sweden Style
Ed. Angelika Taschen

Sydney Style
Ed. Angelika Taschen

Tattoos
Ed. Henk Schiffmacher

Tiffany
Jacob Baal-Teshuva

Tiki Style
Sven Kirsten

Tuscany Style
Ed. Angelika Taschen

Web Design: Best Studios
Ed. Julius Wiedemann

Women Artists
in the 20th and 21st Century
Ed. Uta Grosenick